IMAGES
of America

PERRYVILLE

IMAGES
of America

PERRYVILLE

Alan Fox

ARCADIA
PUBLISHING

Published by Arcadia Publishing
Charleston, South Carolina

Printed in the United States of America

Library of Congress Control Number: 2011931701

For all general information, please contact Arcadia Publishing:
Telephone 843-853-2070
Fax 843-853-0044
E-mail sales@arcadiapublishing.com
For customer service and orders:
Toll-Free 1-888-313-2665

Visit us on the Internet at www.arcadiapublishing.com

This book is dedicated to the photographers of the world, amateur and professional, who have captured on film the ways our lives were lived and the way our world appeared. They are the eyes of history.

CONTENTS

ACKNOWLEDGMENTS

I want to thank all of the people who have so graciously opened their photograph albums and collections to me and to the various institutions that have provided me with images and invaluable background information. Without these people, there could not have been a book. I specifically want to thank the wonderful folks who staff the Historical Society of Cecil County, the Perryville Railroad Museum, and the Town of Perryville for providing me with an unbelievable treasure trove of images and insight for the book. I also thank all who have encouraged me in the course of producing the book. And lastly, I want to thank my wife, Dianne, for listening to me through my manias and depressions, for providing assistance whenever called, and for being the world's greatest cheerleader.

I thank you all so much.

INTRODUCTION

A quick glance at a map of Cecil County, Maryland, will illustrate why Perryville's location on the Susquehanna River was key in the development of the town. To the south of Perryville, the Susquehanna quickly widens and joins with the Chesapeake Bay. This makes any crossing of the waters considerably more difficult. From colonial times, Perryville—then called Lower Ferry—was mainly a location used to transport passengers to and from the other shore of the river. During the American Revolution, George Washington and many of the founding fathers were frequent guests at Rodgers Tavern, located on the east bank of the river in Perryville, in their travels to and from Philadelphia. Previously known as Lower Ferry, Susquehanna, or Chesapeake, the town takes its name from the neck of land south of the ferry called Perry Point.

Perryville grew slowly until the Philadelphia, Wilmington & Baltimore Railroad (PW&B) completed a railroad bridge across the Susquehanna in 1866. Prior to this, railroad cars were transported across the river on ferries, a tedious and time-consuming process. In 1886, the Baltimore & Ohio Railroad (B&O) constructed a bridge several miles to the north. The arrival of the bridges and the town's location on the river allowed Perryville to begin a period of robust growth. By the beginning of the 20th century, Perryville had grown into a bustling railroad village. A rail line running south from Pennsylvania met with the main north-south lines in Perryville, which in turn led to increased rail traffic. Perryville had two large yards where freight trains were broken up and reassembled according to the individual cars' destinations. The railroads and the railroad yards provided Perryville with numerous well-paying jobs.

The Susquehanna River and the Chesapeake Bay also provided employment to Perryville's citizens. Lush aquatic vegetation in the Susquehanna Flats, a shallow body of water located at the confluence of the Susquehanna and the Chesapeake Bay, attracted huge flocks of waterfowl, and the spring spawning runs of fish seemed unlimited. Many locals found a living on the water, through commercial waterfowl hunting in the colder months and commercial fishing during the spring and summer as well as guiding wealthy visiting sportsmen. Much commerce was still conducted via the water during this period, and many locals made a living as boat owners or boat builders. As the town grew, icehouses, a foundry, a cannery, and a fertilizer factory opened, providing other opportunities for employment. By the end of the 19th century, Perryville was established as a robust community. A network of support services sprang up in conjunction with this economic growth. Soon, groceries, hardware stores, barbers, new depots, and more lined Broad Street, the newly developing commercial section of town.

In 1918, the Army Ordnance Corps purchased 500 acres of farmland from the Stump family of Perry Point and began construction of a large chemical plant to produce ammonium nitrate for use in explosives in support of the war in Europe. Once again, Perryville's location determined its destiny, as the Army cited the abundance of fresh water and good railroad facilities as prime factors in selecting the site. Along with the munitions plant, the Army constructed over 300 modern houses for workers, several stores, six boardinghouses, 20 bunkhouses, a kitchen to feed

construction workers, a schoolhouse, a theater, a firehouse, a water plant, and a community clubhouse. Few people are aware of the phenomenal engineering and construction feats that were required to facilitate this construction project. After World War I, the plant was transitioned from a supply depot to a Public Health Department facility and, lastly, to a veterans hospital. Today, the Veterans Administration Hospital at Perry Point remains a vital part of the economic health of the town.

Location continued to be an important factor in the prosperity and growth of Perryville. After an unneeded railroad bridge was converted to vehicular traffic in 1910, the flow of traffic through the heart of the town's commercial district allowed Perryville to remain a well-traveled East Coast corridor, providing for increased commerce. The converted bridge was so heavily traveled that a second deck was added in 1927 to allow two-way traffic. This bridge was so successful that it earned the name "the million-dollar bridge." In 1926, the Federal Highway System was established, and Old Post Road was designated as US Route 40.

In 1940, US 40 was moved a half-mile north and the old route was designated Maryland Route 7. A new toll bridge was opened to carry US Route 40 traffic over the river. The new highway and the growth of automotive travel allowed for a second commercial area to develop in the town. Hotels, motels, gas stations, and diners soon lined the sides of the new Route 40 in Perryville. The period of growth and prosperity lasted only a little over 20 years—when Interstate 95 was opened in 1963, about a mile north of Route 40, Perryville was removed from one of the most heavily travelled motor corridors on the East Coast. Over the next 30 years, with traffic and travelers bypassing the town, Perryville suffered a commercial decline similar to what happened in many other older towns and cities. Although Perryville has experienced a surge of new growth in recent years, the older sections of town are still in need of revitalization.

In the course of completing this book, I have managed to collect a wonderful selection of vintage images that have been graciously provided by interested citizens and organizations. These images trace a great deal of the history of Perryville and nearby neighborhoods. It is my sincere wish that the photographs in this book will put a more human face on the history of Perryville and its citizens and that Perryville's history becomes more than mere facts and figures but an entity that is animated and alive.

One

The Susquehanna

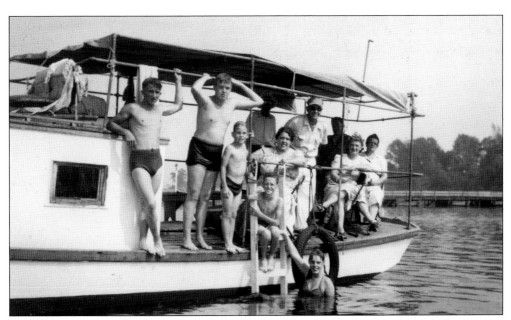

Pleasure Boating. The Susquehanna offers wonderful opportunities for recreation. Swimming, hunting, sport fishing, crabbing, and boating were enjoyed through the years by many of Perryville's residents. In this 1946 picture of a boating party, George Bailey (in sunglasses) and other adults watch over a group of youngsters enjoying a refreshing summer dip. (Courtesy of Wilma Denton.)

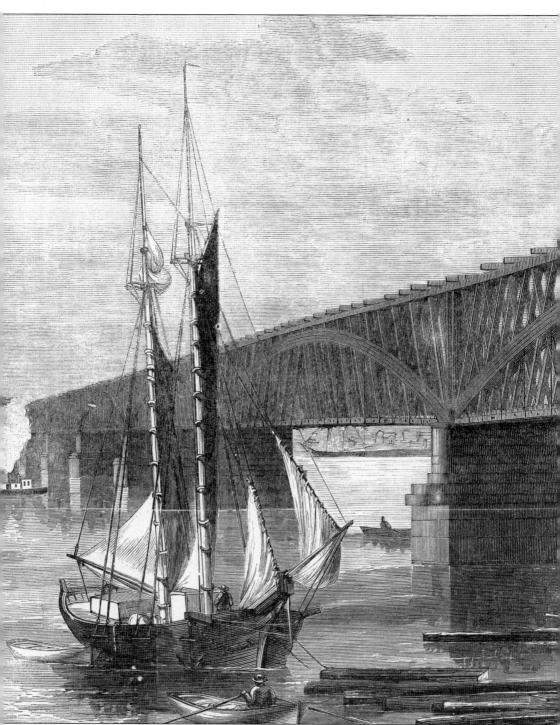

First Bridge over the Susquehanna River at Perryville. Spanning over 3,000 feet from shore to shore and costing $1.5 million, this railroad bridge was hailed as a masterpiece of strength, safety, and beauty at the time of its 1866 opening. Prior to completion, the nearly-finished span was destroyed by a tornado, but it was rebuilt. A new bridge designed for heavier rail traffic was

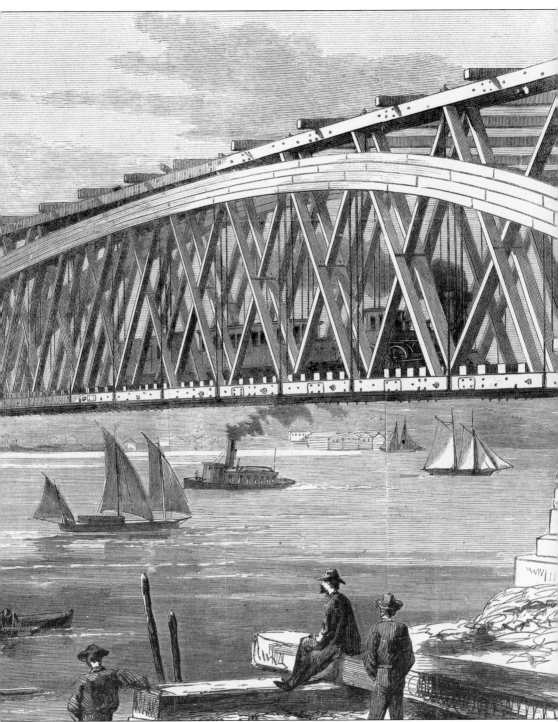

built alongside this bridge in 1906. Since it was no longer needed for rail traffic, this bridge was converted for automotive use. Ten boats can be counted in this wood engraving, an excellent indication of how important the Susquehanna River was to commerce in the area. This illustration ran in the December 22, 1866, edition of *Harper's Weekly*. (Courtesy of the author.)

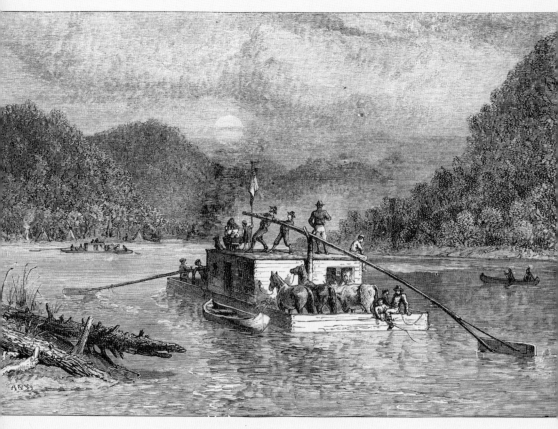

FLAT-BOATING ON THE SUSQUEHANNA.

FLATBOATING ON THE SUSQUEHANNA RIVER. This 19th-century wood engraving shows a flatboat crew guiding their craft down the Susquehanna. Using only the river's current for propulsion, they employed large oars fore and aft to steer their craft. The Susquehanna is usually too shallow and rocky to be suitable for commercial navigation above Port Deposit, but river arks and flatboats, loaded with goods for sale, took advantage of high waters in the spring to take a one-way trip down the river to do business. The cargo—often grain, pork, beef, whiskey, or lumber—was sold and the craft dismantled and sold for lumber. The crew then typically walked back up north. While these boats afforded Perryville access to goods from a market not easily accessed by other means, the growth of the railroads and canals led to their demise. (Courtesy of the author.)

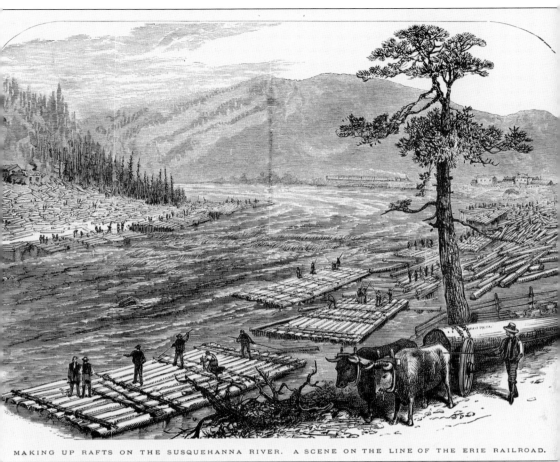

MAKING UP RAFTS ON THE SUSQUEHANNA RIVER. A SCENE ON THE LINE OF THE ERIE RAILROAD.

LOG RAFTS ON THE SUSQUEHANNA. Starting in the early 1800s, log and lumber rafts were assembled in the logging camps along the upper reaches of the Susquehanna for a journey downriver on the spring floodwaters to ports in Maryland. Many areas of northern Maryland had been logged out for years, and a valuable market existed there for wood. Although most of this lumber was not destined for Perryville, logs that had broken loose from a raft or escaped from a boom were fair game and free to anyone who plied the river. One can still find older houses in Perryville with white pine logs, which had floated down the river, serving as floor joists or other structural elements. Local decoy carvers were especially fond of the soft, easily worked wood, and many Perryville decoys started life in a Pennsylvania or New York forest. By the end of the century, the growth of rail lines along the river brought a virtual end to rafting. (Courtesy of the author.)

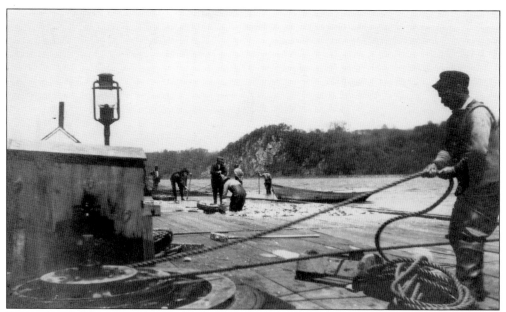

FISHERMEN AT WORK ON A FISHING FLOAT, C. 1910. First used in the 1820s, floats were constructed of logs fashioned into a raft and decked with planks. The floats, anchored close to the nets, proved to be a highly effective method of harvesting and processing the vast schools of herring and shad that swam up the Susquehanna each spring to spawn. (Courtesy of Historical Society of Cecil County.)

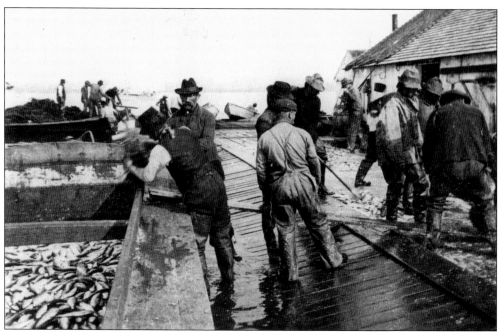

FISHING FLOAT ON THE SUSQUEHANNA, C. 1910. The fishing floats were essentially water-borne factories where fish were cleaned, salted, and packed in barrels as soon as they were brought up in nets. Commercial netting using floats proved to be so effective that the Susquehanna fishery was severely damaged. (Courtesy of Historical Society of Cecil County.)

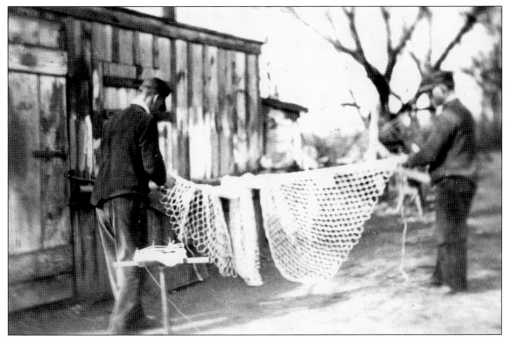

FISHERMEN MAKING NETS, C. 1910. Commercial netting took a toll on equipment, and commercial fishermen were constantly making new nets and traps or repairing older ones. This photograph from the early 1900s shows a pair of fishermen making nets in anticipation of the upcoming season. (Courtesy of Wilma Denton.)

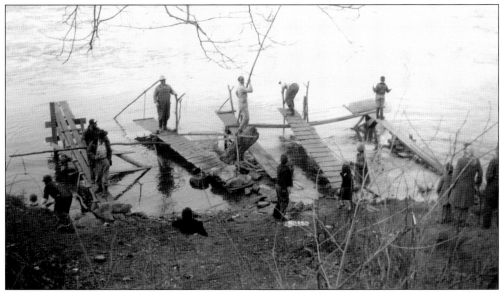

DIP-NETTING ON THE SUSQUEHANNA, 1952. Springtime brought spawning herring and shad up the rivers of Cecil County from the ocean. Standing on flimsy piers, these Susquehanna fishermen try their luck at landing a mess of fish to be smoked, pickled, or eaten fresh. (Courtesy of the author.)

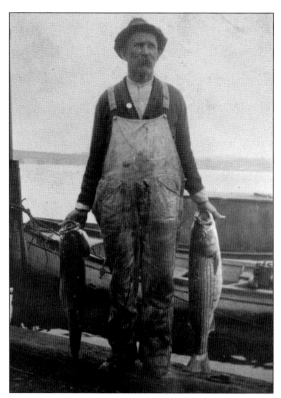

DAY'S CATCH, c. 1935. Although fishing had declined to only a percentage of what it had been decades before, commercial fishing continued, on a smaller scale, in the Susquehanna. This fisherman brings in several nice rockfish from his boat, the *Restawhile*, for sale to a local fish house. (Courtesy of Wilma Denton.)

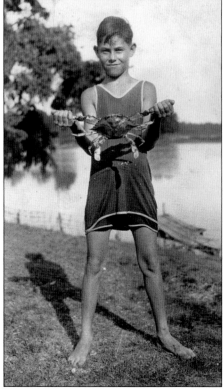

BLUE CRAB, c. 1930. A young boy proudly displays a large blue crab for the photographer. Locals have long been fond of dining on blue crabs and of running a trot line or tending pots to catch them. This monster was undoubtedly steamed soon after this picture was taken. (Courtesy of Wilma Denton.)

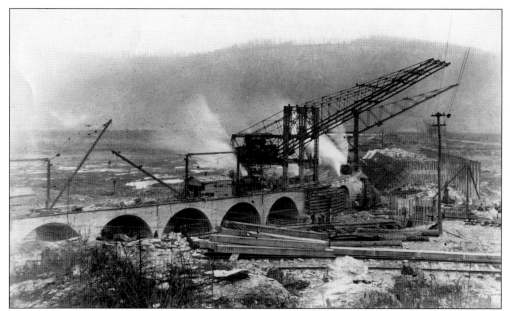

CONSTRUCTION OF CONOWINGO DAM, C. 1927. The 1928 completion of the Conowingo Dam completely halted the migrations of the huge schools of shad, herring, and other fish on spawning runs up the Susquehanna into Pennsylvania and New York. Combined with overfishing, this resulted in the collapse of the Lower Susquehanna Valley fishery, which had provided gainful employment to many Perryville men. (Courtesy of Historical Society of Cecil County.)

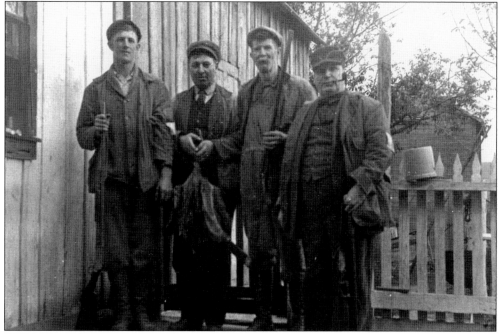

WATERFOWL HUNTERS, C. 1910. A quartet of hunters poses for a photograph at a fishing shanty on the shore of the Susquehanna. Waterfowl hunting has always been a popular sport in Perryville; the town's proximity to the world famous Susquehanna Flats made it an East Coast hotspot for gunning down ducks and geese. (Courtesy of Wilma Denton.)

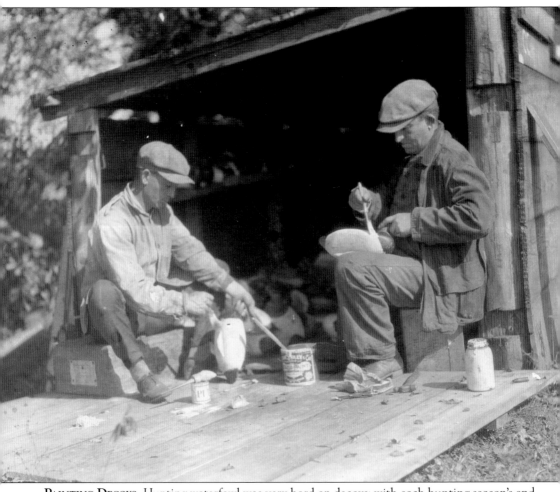

PAINTING DECOYS. Hunting waterfowl was very hard on decoys; with each hunting season's end, waterfowlers were left with a number of decoys that needed to be repaired, repainted, or replaced. In this undated photograph, George Thompson (left) and Abner Burrows put a fresh coat of paint on canvasback decoys at a makeshift shanty on the Susquehanna shore. Today, vintage decoys are sought-after collectibles and often bring surprisingly high prices in antique shops or at auction. Perryville decoy makers, such as Taylor Boyd, Henry Davis, and Ben Dye, have become well known among collectors. (Courtesy of Historical Society of Cecil County.)

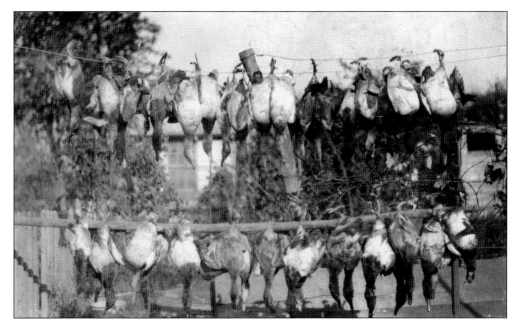

A DAY'S DUCK-HUNTING. Thirty-seven canvasback ducks—this was not an unusual day's take for a Perryville hunter. The Susquehanna Flats were once the winter home of about half of the North American canvasback population, but overhunting, the decline of wild celery, and compromised water quality have decimated the population. (Courtesy of Wilma Denton.)

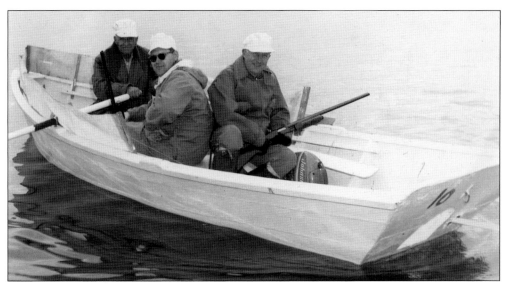

HUNTING ON THE SUSQUEHANNA FLATS, EARLY 1960s. Although duck hunting had fallen off from what it was in the glory days, these executives from Philadelphia Gas and Electric Company traveled to Perryville for a day of gunning on the flats. They were guided by Walter Hornbarger (left), a longtime Perryville waterman and hunter. (Courtesy of Jim Hornberger.)

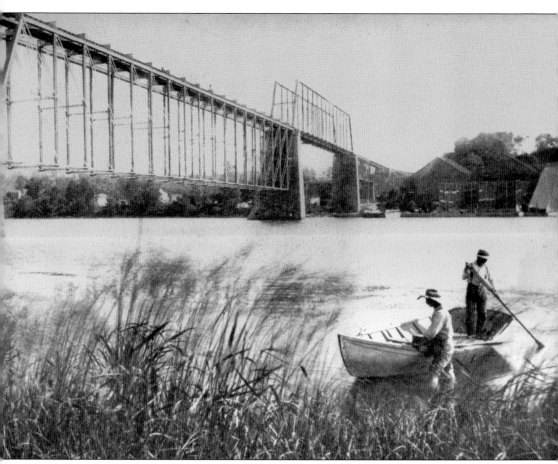

BOATERS AT GARRETT ISLAND, C. 1900. Two men in a small rowboat prepare to beach their craft on the shores of Garrett Island. In the 1880s, the B&O Railroad purchased the island for use in building a bridge across the Susquehanna River and renamed it in honor of former B&O president John W. Garrett. The American Ice Company's buildings can be seen on the far shore, just to the right of the railroad bridge. In 2005, the 198-acre island was purchased by the US Fish and Wildlife Service and is now protected as a national wildlife refuge. (Courtesy of Jim Boyd.)

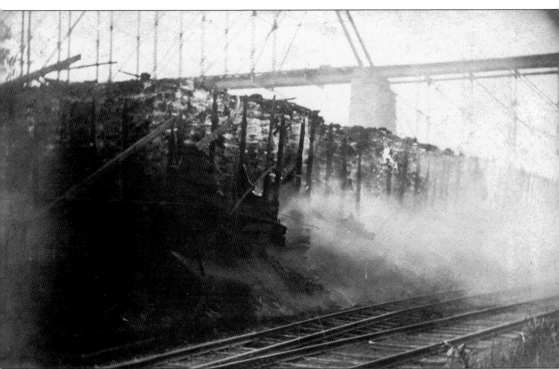

FIRE AT THE AMERICAN ICE COMPANY, 1906. The burning of the American Ice House was described by one resident as a disastrous fire that could be seen throughout town. Property owners furiously worked to keep windblown embers and burning material away from businesses and homes. The B&O railroad bridge is visible in the background. (Courtesy of Historical Society of Cecil County.)

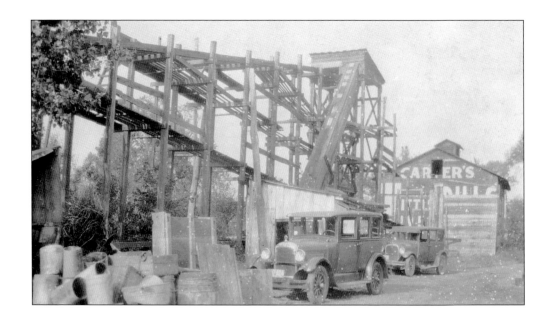

ICE COMPANY, C. 1935. These photographs are of an ice company that was located on the present-day site of the Owens Landing condominiums. The three Perryville ice companies, with work including cutting, storing, and selling ice, provided employment for many local men. A.H. Owens & Son acquired this property for a marina and fish house after the icehouse closed. The lettering on the building in the above photograph was originally advertising for Carter's Little Pills, meant to be seen from the railroad bridge to the south. (Above, courtesy of Historical Society of Cecil County; below, courtesy of Wilma Denton.)

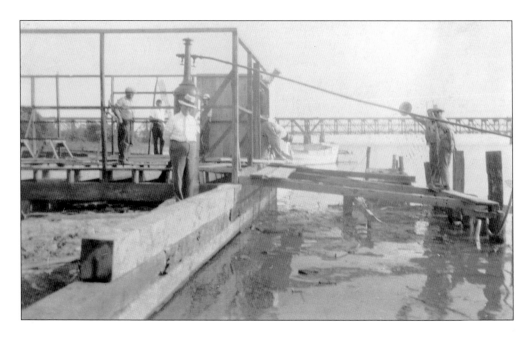

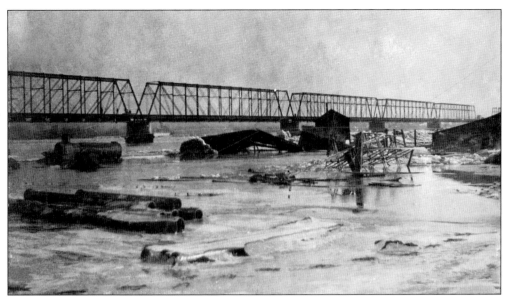

ICE ON THE RIVER, C. 1900. Although winter freezes provided the Perryville icehouses with a valuable product, ice on the river had the potential to cause grave damage. In this photograph, ice has inflicted damage to several structures on the shore. The iron Philadelphia, Wilmington & Baltimore Railroad bridge, built in 1880, is in the background. (Courtesy of Wilma Denton.)

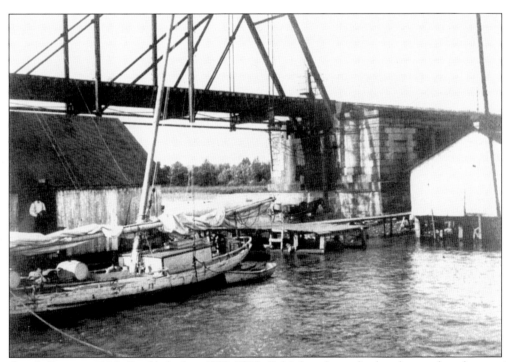

COLE'S PIER, C. 1900. Established in 1889, W.H. Cole's bought seafood and game from hunters and fishermen and packed the items for shipping all over the country. The *Perryville Record*, a newspaper of that era, noted that "the highest prices are always paid for consignments." (Courtesy of Wilma Denton.)

23

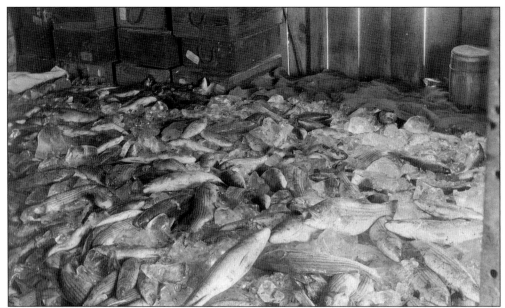

THE BOUNTY OF THE WATERS. The Chesapeake and the Susquehanna once provided Perryville's citizens with jobs, food, and recreation. Here, a fresh catch of striped bass (locally known as rockfish) glistens in the iced storage area of Will Cole's Fish House. Unfortunately, the once-abundant seafood has been dramatically reduced over the years. (Courtesy of Wilma Denton.)

Terms cash, and weekly, to approved credit.

We pay Fishermen cash, and must collect our cash to keep credit good.

Fresh Fish received daily, and mostly from Susq. River and Chesapeake Bay, always on hand. Oysters and Crabs in season.

A. H. OWENS & SON

National Cash Register Co., Dayton, Ohio

TERMS OF THE SALE, 1950. The reverse side of 1950s receipts from A.H. Owens & Son's fish house spelled out terms of a sale in no uncertain words. Variety, availability, and reasonable prices made fresh seafood a staple of many Perryville residents' diets. (Courtesy of the author.)

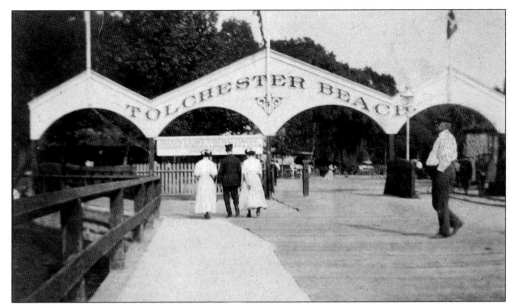

ENTRYWAY TO TOLCHESTER BEACH, C. 1900. As steamship travel became popular on the Chesapeake Bay, Tolchester Beach, in Kent County, became a favorite destination for Perryville residents, with hotels, restaurants, and facilities for games, picnics, and horse-racing. The amusement park featured a merry-go-round and roller coaster, as well as a shooting gallery and bowling alley. (Courtesy of Wilma Denton.)

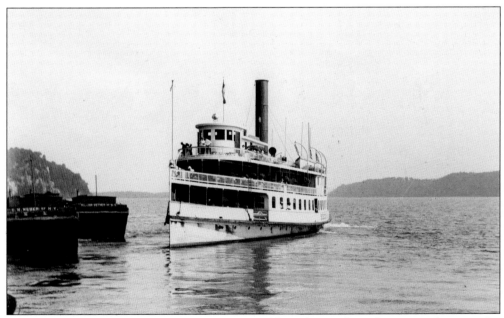

MIDNIGHT EXCURSIONS AND PLEASURE CRUISES. Plying her trade on her namesake river, the *Susquehanna* nears a dock to discharge and take on passengers. Moonlight excursions featuring orchestra music and dancing were among the more enjoyable summertime activities available to Perryville citizens. (Courtesy of Historical Society of Cecil County.)

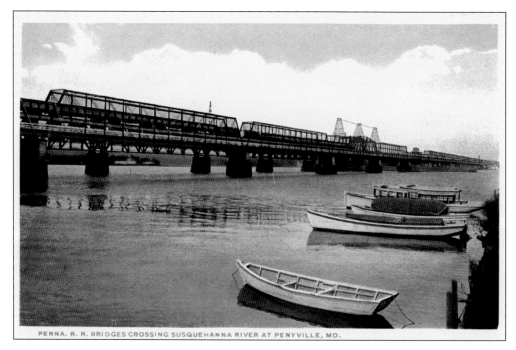

PENNA. R. R. BRIDGES CROSSING SUSQUEHANNA RIVER AT PENYVILLE, MD.

THE TWIN BRIDGES. The construction of a new railroad bridge in 1906 resulted in a pair of parallel bridges that became known as the twin bridges. The bridges made for a unique and picturesque scene and were the subject of many picture postcards from the era. These postcards from the early 1900s offer two examples. The above photograph was taken from the Harford County side of the Susquehanna, and the below photograph was taken from the Perryville side. (Both, courtesy of the author.)

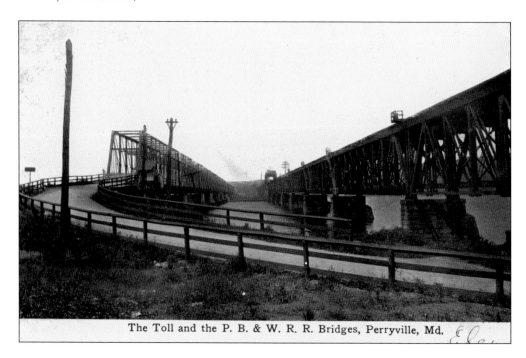

The Toll and the P. B. & W. R. R. Bridges, Perryville, Md.

Two

A RAILROAD TOWN

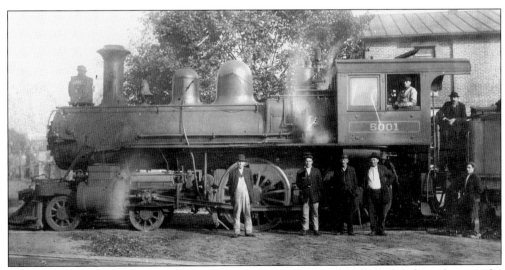

A STEAM LOCOMOTIVE AT THE BROAD STREET CROSSING, C. 1915. Railroad employees take time to pose for a photograph at the intersection of Front and Broad Streets before entering the Perryville freight yard. The importance of the railroads to the growth of Perryville can hardly be overstated; they provided employment, spurred commerce, and offered convenient transportation. (Courtesy of Terry Hornberger.)

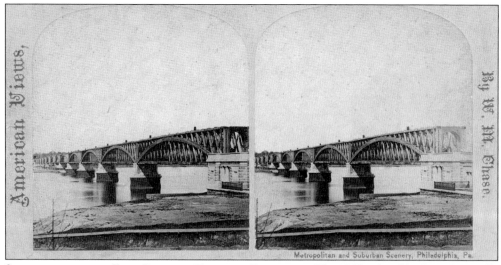

Stereograph of the First Railroad Bridge at Perryville. The 1866 railroad bridge at Perryville was captured in this stereographic image. This wooden structure was replaced in 1880 with a more durable iron span. This is believed to be one of a set of stereographs of interest to residents in the greater Philadelphia area. This bridge allowed travel from Philadelphia to Washington for the first time without the interruption of a ferry crossing at the Susquehanna. (Courtesy of Perryville Railroad Museum.)

Perryville's First Railroad Station, 1866. A simple wooden structure, the Philadelphia, Wilmington & Baltimore Railroad station was located near the new bridge. Its wooden arches and supports can be seen in the middle background of this stereograph. These dual images were viewed through an optical device that merged the images into one, producing the illusion of depth. (Courtesy of Perryville Railroad Museum.)

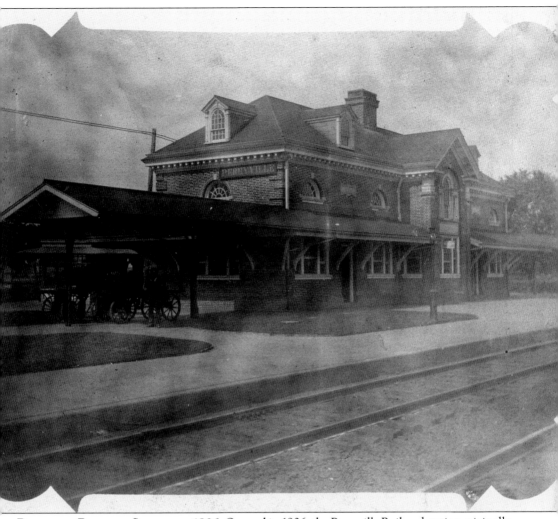

PERRYVILLE RAILROAD STATION, C. 1906. Opened in 1906, the Perryville Railroad station originally served the PW&B Railroad, but is best known for its service to the Pennsylvania Railroad. In the heyday of train travel, the station was the site of nearly constant activity. A picturesque brick structure, it was restored in 1991 after being completely out of service for years and now serves as a stop for MARC and Amtrak trains. (Courtesy of Historical Society of Cecil County.)

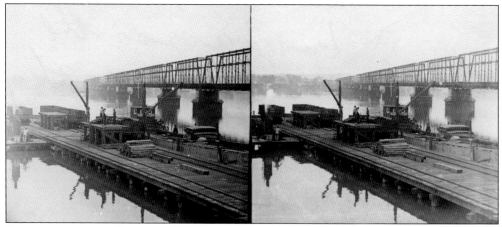

STEREOGRAPH OF THE RAILROAD PIER. Before the construction of the railroad bridge (seen to the right), the railroad relied on ferries to carry railroad cars across the river. After 1866, the pier was used as a utility dock and a steamship landing, as well as a site for shipping and receiving railroad goods by water. In this stereograph, workers remove cross ties from a boat and load them onto a railcar. (Courtesy of Historical Society of Cecil County.)

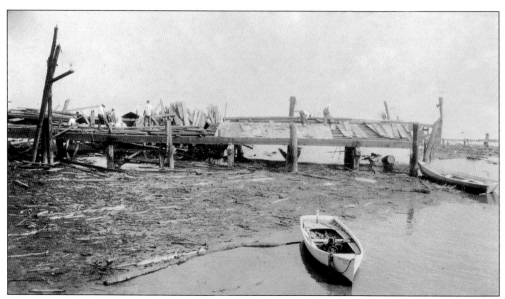

DEMOLISHING THE RAILROAD PIER. Because the railroad no longer had to cross the Susquehanna by ferry, the need for the railroad pier was gone. This photograph from the 1930s shows workmen removing the large deck planks from the framework of the pier. The remains of the pilings that supported the pier can still be seen at low tide. (Courtesy of Wilma Denton.)

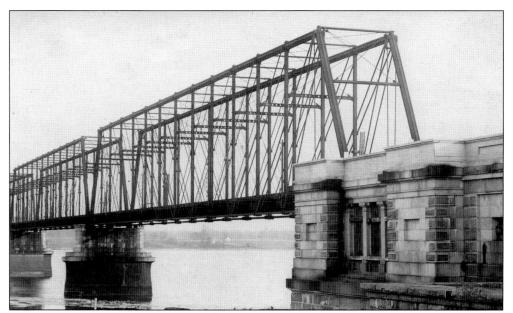

IRON BRIDGE, C. 1880. In 1880, the wooden spans of the first railroad bridge were replaced with iron, a more durable material. The upgrade resulted in a more graceful bridge; the quality of the stonework on the abutment is indicative of the importance of aesthetics in 19th-century design. (Courtesy of Historical Society of Cecil County.)

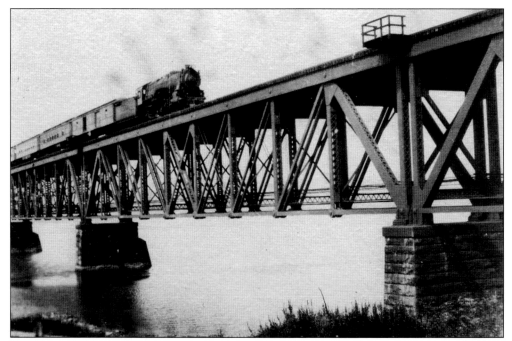

THE FIRST TRAIN TO CROSS THE NEW RAILROAD BRIDGE. In 1906, a passenger train pulled by a steam locomotive, thunders over the Susquehanna toward Perryville on the newly constructed Pennsylvania Railroad bridge. (Courtesy of Historical Society of Cecil County.)

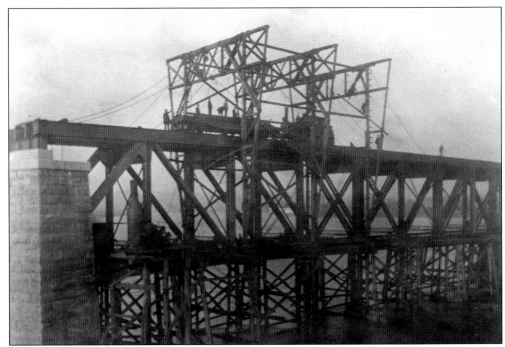

Construction of the Pennsylvania Railroad Bridge. The new steel railroad bridge, completed in 1906, is shown here while under construction. The construction was facilitated by a steam-powered structure known as the Traveller, which allowed components to be put into position as construction progressed. (Courtesy of Wilma Denton.)

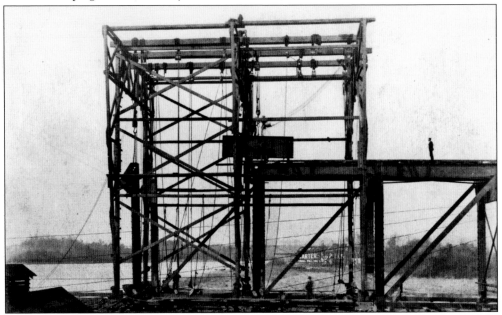

The Traveller. This postcard shows a more detailed view of the Traveller. The complex arrangement of pulleys, supported by a structure that rose from the bottom of the bridge to well above the top deck, allowed steel beams to be lifted and fixed into place with bolts or rivets. The size of this mechanism can be judged by the size of the men standing next to it. (Courtesy of Ray Keen.)

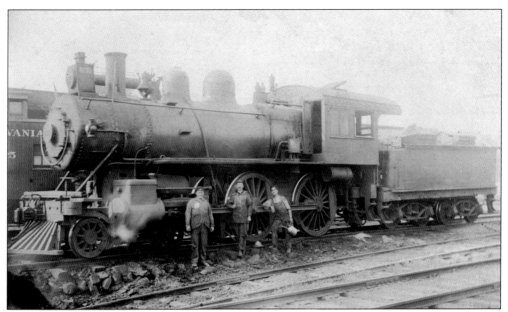

STEAM ENGINE CREW, C. 1915. Arthur Sentman (left), a Pennsylvania Railroad engineer, and his crew stand in the Perryville freight yard. This photograph is an excellent illustration of the size and might of the steam-powered locomotives of the era. With drive wheels as tall as a man—and belching steam, smoke, and sparks—they were formidable to behold. (Courtesy of Historical Society of Cecil County.)

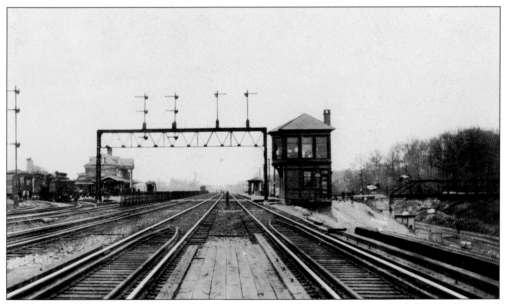

NORTHWARD VIEW OF THE TRAIN STATION, C. 1920. The station is on the left and the signal tower is on the right in this early photograph. The old bridge that was the main entrance to Perry Point at this time can be seen at far right in the photograph. (Courtesy of Historical Society of Cecil County.)

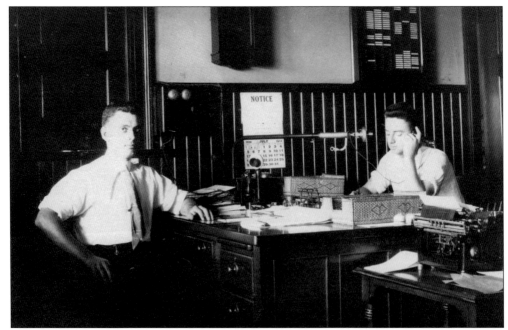

RAILROAD CLERKS, JULY 1914. In direct contrast to the gritty, dirty work required by much of the railroad's labor force, paperwork was also necessary to keep the railroad working. These two clerks at the Perryville train station were photographed in clean white shirts and ties. (Courtesy of Historical Society of Cecil County.)

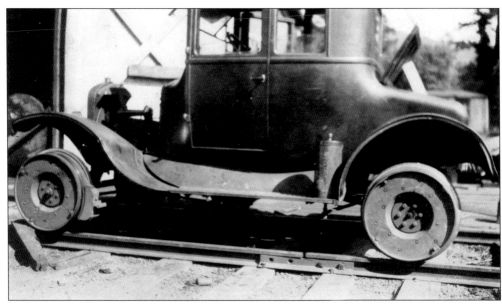

MODEL T CONVERTED FOR THE RAILROAD. The railroad employed many talented machinists and mechanics to keep the locomotives and other equipment in good repair. This photograph of a Ford Model T converted to operate on railroad tracks, taken in the Perryville freight yard, is an example of the workers' skills and ingenuity. (Courtesy of Historical Society of Cecil County.)

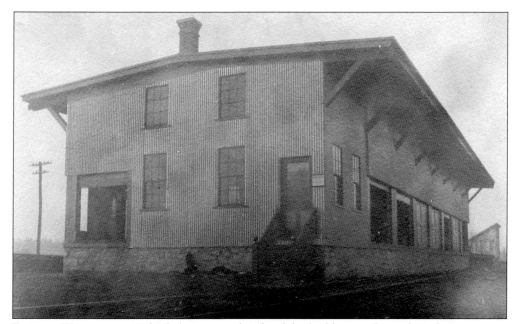

Freight Warehouse. Multiple bays on each side of the building made it relatively convenient for freight cars to be pulled alongside this warehouse, where cargo could be loaded and unloaded as necessary. A simple building of corrugated metal and wood, it was a model of utilitarian construction. (Courtesy of Historical Society of Cecil County.)

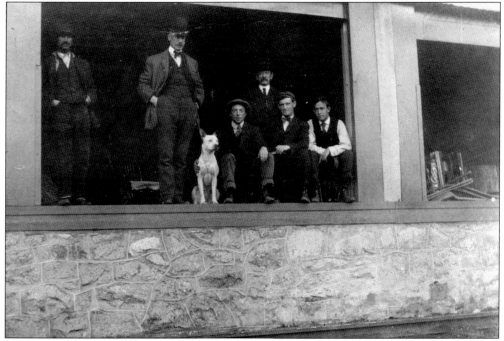

Freight Warehouse in the Perryville Railroad Yard, c. 1910. Workers pose in one of the loading bays of the large Pennsylvania Railroad warehouse in the Perryville yard. Cargo transfers between freight cars from various railroads' connections were made in this building. (Courtesy of Wilma Denton.)

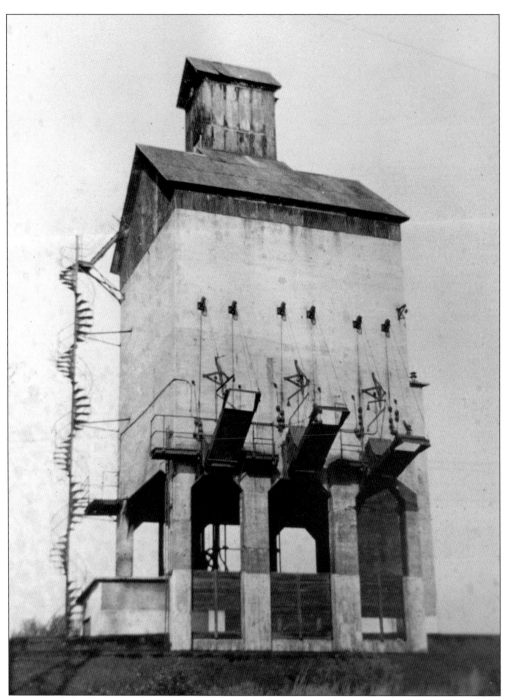

COAL TIPPLE. This undated photograph shows the massive coal tipple that dominated the large Pennsylvania Railroad freight yard that ran between Front Street and the Susquehanna River. The towering structure was constructed of cast concrete and stood four stories tall. It was built to provide steam engines with coal, which was stored in the top section. The coal was then loaded into tenders by means of chutes. As the steam age passed, there was no longer a need for the tipple, and it was torn down in the mid-1950s. (Courtesy of Perryville Railroad Museum.)

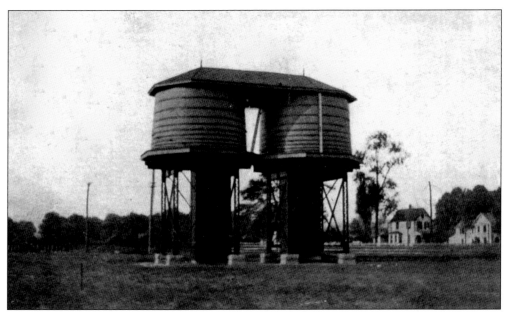

THE WATER TOWERS. In addition to the coal needed to fire the boiler, steam engines needed water to produce steam. These two Pennsylvania Railroad water towers sat near the train station, ready to provide locomotives with the water that would allow them to proceed to their destinations. (Courtesy of Perryville Railroad Museum.)

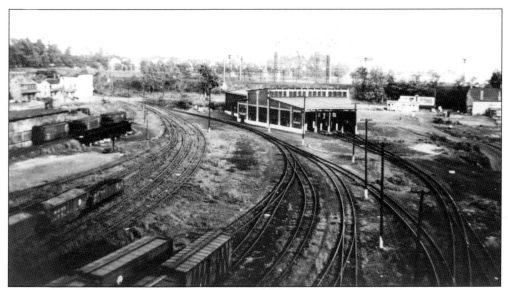

PERRYVILLE FREIGHT YARD. Looking south, this photograph shows the Perryville freight yard and roundhouse. The yard ran three quarters of a mile north from the roundhouse on Broad Street. This large yard gave Front Street, which bordered it on the east, its local nickname of "Box Car Avenue." Letters intended for residents of Front Street but addressed to "Box Car Avenue, Perryville, Maryland," were not uncommon. (Courtesy of Perryville Railroad Museum.)

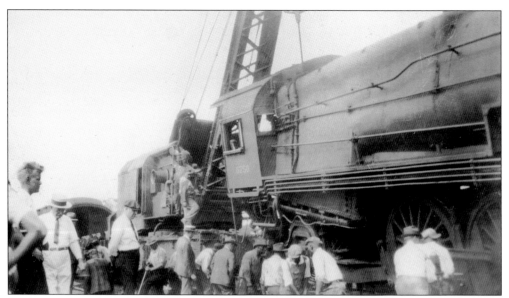

DERAILED TRAIN, C. 1935. This photograph shows curious onlookers watching as a crew works to place a derailed locomotive back on the tracks. The derailment occurred just before crossing over Broad Street toward the main line. Despite being romanticized in song, cinema, and literature, railroad work could be hard, gritty, and, in some instances, very dangerous. (Courtesy of Wilma Denton.)

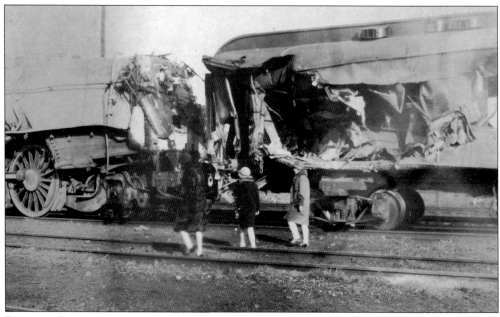

DAMAGED ENGINE AND CAR. Accidents on the railways were capable of inflicting extensive damage to equipment and serious injury or death to employees or passengers. This 1930s photograph from the Perryville Freight Yard shows three women inspecting a damaged locomotive and mail car after an accident. (Courtesy of Wilma Denton.)

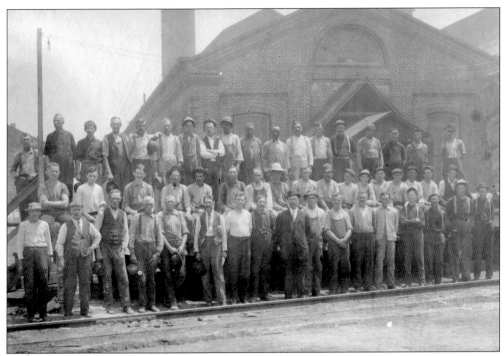

PERRYVILLE ROUNDHOUSE, C. 1910. Railroad workers gather for a photograph outside the roundhouse in the Perryville Freight Yard. Because steam locomotives lacked a reverse capability, they could only move forward. A roundhouse was used to change the direction of a locomotive by utilizing a large rotating platform known as a turntable. After entering the roundhouse and moving onto the turntable, locomotives were turned toward the direction required and moved back onto a track. (Courtesy of Town of Perryville.)

THE ROUNDHOUSE IN 1970. With the passing of the steam locomotive, the roundhouse was no longer a vital part of railroad operations. By the 1960s, the old building was being used for storage and office space. It was demolished in the 1990s. (Courtesy of Historical Society of Cecil County.)

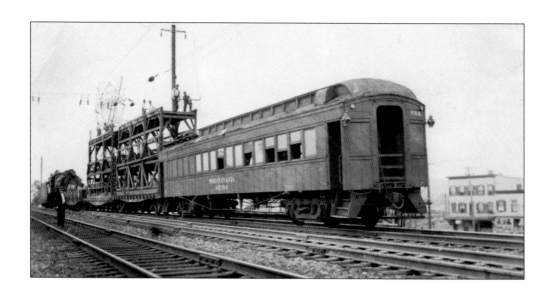

ELECTRIFICATION OF THE PENNSYLVANIA RAILROAD, 1935–1936. The Pennsylvania Railroad electrified all lines located east of Harrisburg, Pennsylvania, in the 1930s. Here, workmen on the tracks in Perryville install the electric lines that would soon power locomotives. Electrical power was transmitted from the overhead power lines to the train through a device called a pantograph that was mounted on the top of the locomotive. Although steam locomotives would remain active for several more years, the age of electric and diesel locomotives was fast approaching. (Both, courtesy of Historical Society of Cecil County.)

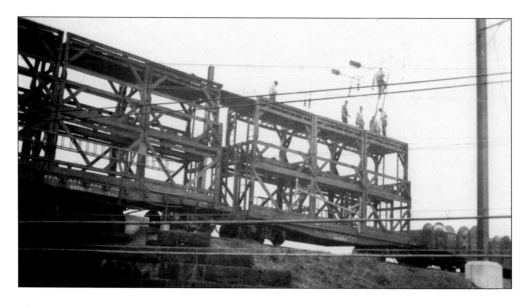

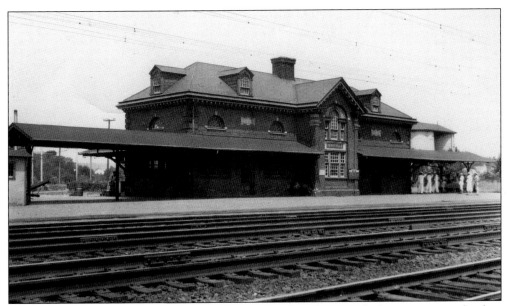

PERRYVILLE RAILROAD STATION, WORLD WAR II. This photograph shows a group of sailors from Bainbridge Naval Training Center awaiting a train. The station was a beehive of activity during the war, moving sailors and supplies in support of the war effort. (Courtesy of Perryville Railroad Museum.)

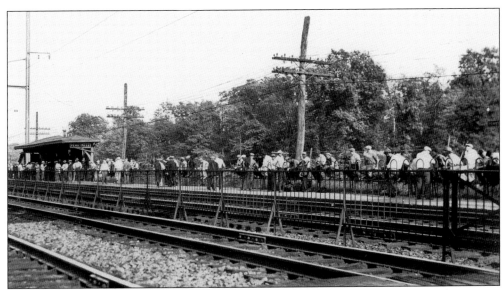

WAITING FOR A NORTHBOUND TRAIN. A crowd awaits the arrival of a northbound train during World War II. The small sheltered waiting area, seen at left in the photograph, was far too small to accommodate the mass of passengers lining the tracks. (Courtesy of Historical Society of Cecil County.)

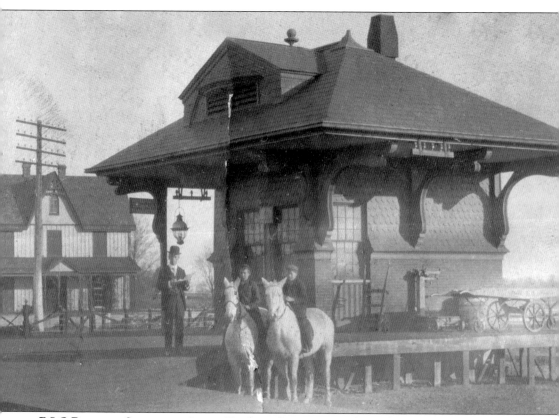

B&O Railroad Station at Aiken. Youths on horses pose in this early view of the B&O Railroad depot at Aiken. Although it was never as big a presence in Perryville as the Pennsylvania Railroad, the B&O provided freight and passenger service to the town. One of the oldest railroads in the nation, the B&O was absorbed by the CSX transportation network in 1987. Aiken was incorporated into Perryville in 1962. (Courtesy of Historical Society of Cecil County.)

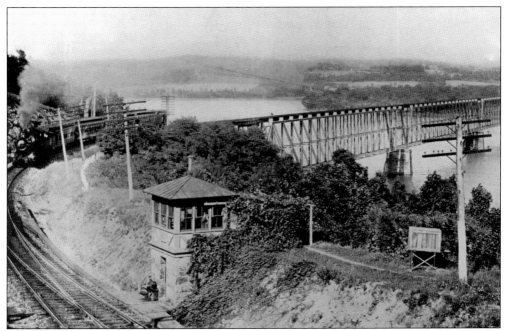

THE B&O CROSSES THE SUSQUEHANNA. This photograph, taken from the Harford County side of the Susquehanna, shows a steam locomotive and train coming off the B&O bridge. Completed in 1886, the deck stood nearly 100 feet above the water. The height of the bridge allowed it to be built without the draw mechanism used by earlier bridges. (Courtesy of Jim Boyd.)

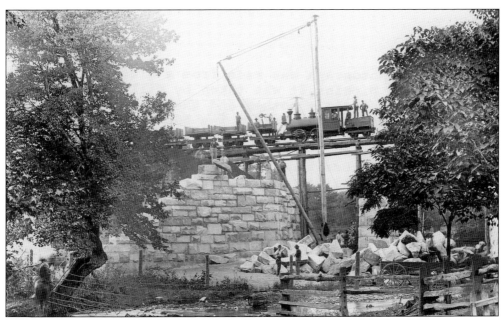

BRIDGE AT CEDAR CORNER ROAD, C. 1884. As a work-train crew watches from a temporary set of tracks, a simple wooden crane lifts large stone block to a masonry crew. The masons are building the abutments of the B&O bridge over Cedar Corner Road. (Courtesy of Town of Perryville Archives.)

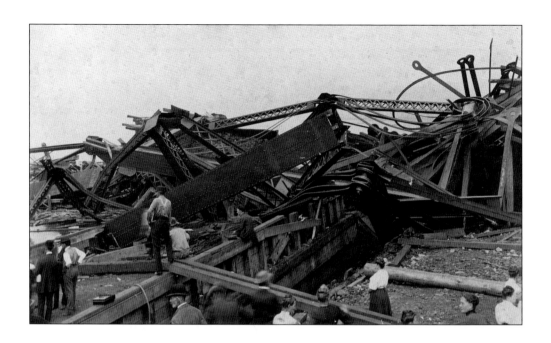

B&O Railroad Bridge Collapse. In September 1908, there was a calamitous collapse of the B&O Railroad Bridge that spanned the Susquehanna between Perryville and Havre de Grace. Railroad cars and bridge debris were strewn on the Perryville shoreline and in the river. For days, curious sightseers flocked to the scene of the accident to get a look at the wreckage. These photographs show the onlookers the wreck attracted, as well as the massive damage to the bridge. (Both, courtesy of Jim Eberhardt.)

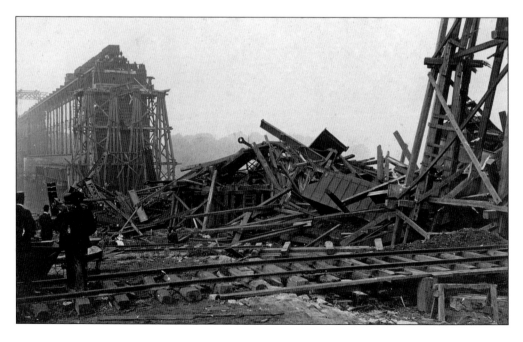

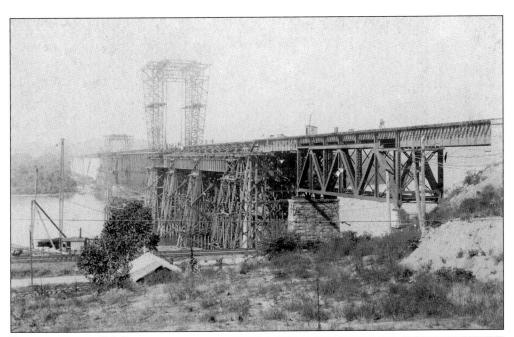

REBUILDING THE B&O BRIDGE. After the collapse of the bridge, an intensive operation began to replace the bridge with a new, more substantial span. In the above photograph, wooden scaffolding and pilings secure the new structure as metal beams are put into position. (Courtesy of Historical Society of Cecil County.)

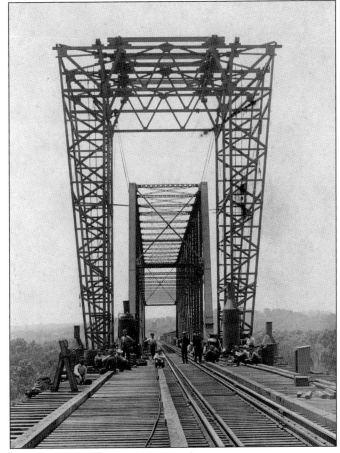

CONSTRUCTION OF THE NEW BRIDGE IN PROGRESS. A large framework structure designed to move heavy timbers and beams into position was employed in the new bridge's construction. Using steam-powered block and tackle, much of the rebuilding was completed from the existing deck of the damaged span. (Courtesy of Jim Eberhardt.)

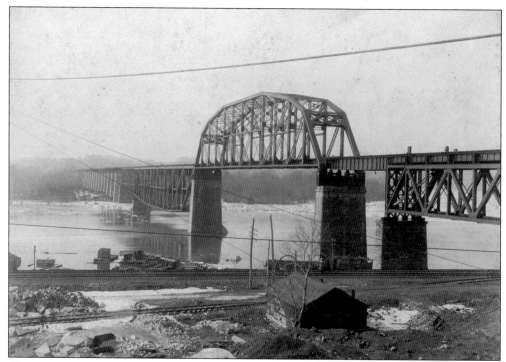

COMPLETION OF THE NEW B&O BRIDGE. The new bridge was finished and opened to rail traffic on January 6, 1910—just over 15 months after the collapse. The short span of time needed to complete a project of this magnitude remains a remarkable accomplishment. (Courtesy of Historical Society of Cecil County.)

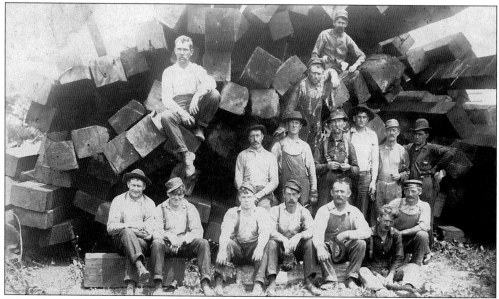

B&O SECTION GANG, C. 1906. Working locally or covering large areas of track and roadbed while in a cabin car, section gangs were responsible for inspections, repairs, and/or replacement of tracks and roadbeds. This crew has taken time from its vital work to pose on a large pile of cross ties. (Courtesy of Jim Eberhardt.)

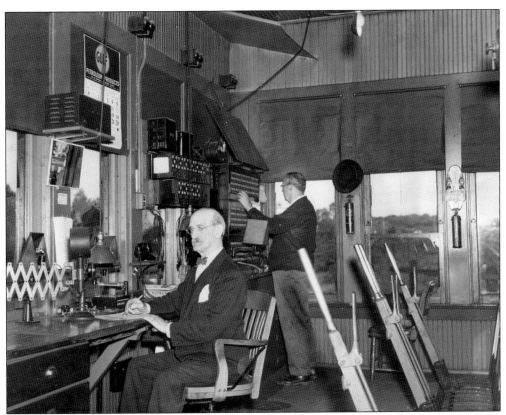

B&O Signal Tower, 1946. William L. Taylor (left), a day operator, and Thomas Taney, a Western Union operator, work in the signal tower at Aiken. Operators were responsible for the control and coordination of all railroad traffic in their assigned areas. (Courtesy of Historical Society of Cecil County.)

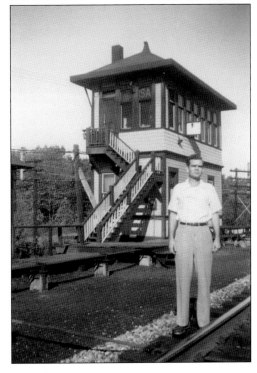

B&O Signal Tower, 1953. Squeezed between the railroad tracks and Sumter Drive, the Perryville signal tower was a handsome wooden structure featuring an exterior stairway. It was torn down in the 1960s. Longtime B&O employee Dewey Triplet stands beside the tracks. (Courtesy of Historical Society of Cecil County.)

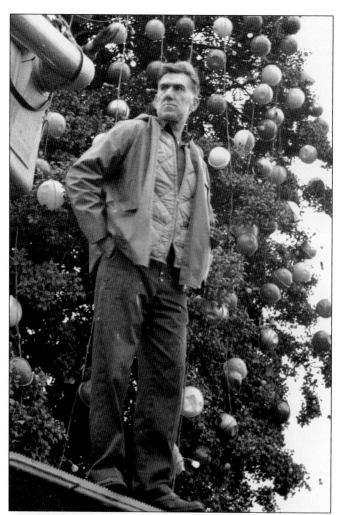

THE TRAVELERS' CHRISTMAS TREE, 1972. James Thomas supervises volunteers decorating the 55-foot-tall Travelers' Christmas Tree for the holiday season. The holly tree is owned by the B&O, and the tree-lighting ceremony has been a cherished local tradition since 1948. (Courtesy of Historical Society of Cecil County.)

PASSING THE HOLLY TREE, 1972. From the caboose of a train, railroad employees wave at the volunteers decorating the famous holly tree for the Christmas season. For many years, the Travelers' Christmas Tree greeted passengers on the B&O during the holidays. (Courtesy of Historical Society of Cecil County.)

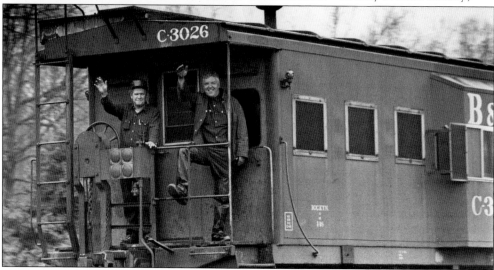

Three

COMMERCE

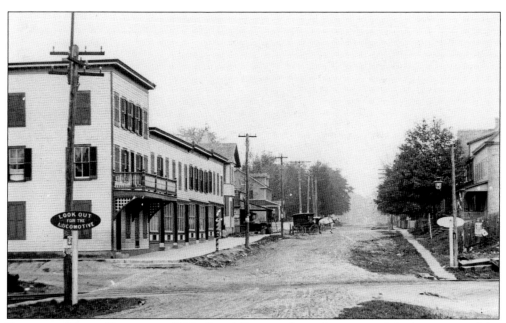

BOARDING HOUSE CORNER, C. 1900. Broad Street is shown here around the beginning of the 20th century, looking east from the corner of Front Street. This single block of Broad Street between Susquehanna Avenue and Front Street was the hub of much of the commercial activity in Perryville at the time. This block once contained a bank, a post office, a restaurant, two grocery stores, two hardware stores, two barbershops, a variety store, a drugstore, and a news depot. Rooms were available for rent in the second and third stories of the row house at left in the photograph, leading to this intersection's local dubbing as "Boarding House Corner." (Courtesy of Town of Perryville.)

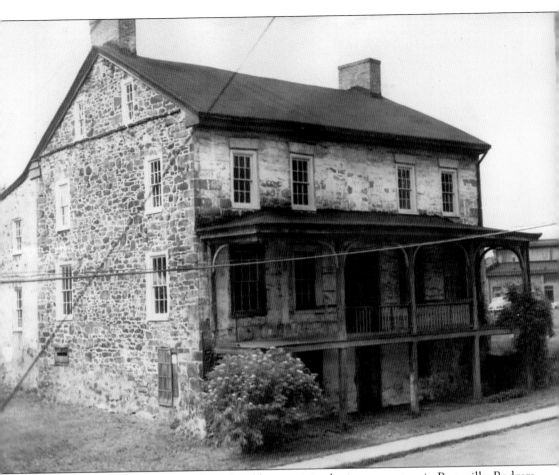

RODGERS TAVERN, C. 1950. Perhaps the oldest surviving business structure in Perryville, Rodgers Tavern was built in the mid-1700s, served as an inn at a ferry stop during the Colonial period, and was continuously occupied for nearly 200 years. The tavern was abandoned and had fallen into a state of disrepair by the 1950s. This photograph was taken before the Friends of Rodgers Tavern purchased the structure from the Pennsylvania Railroad in the mid-1950s and began an extensive rehabilitation of the old fieldstone roadhouse. Now owned by the town of Perryville, the building's restoration continues to this day. (Courtesy of Town of Perryville.)

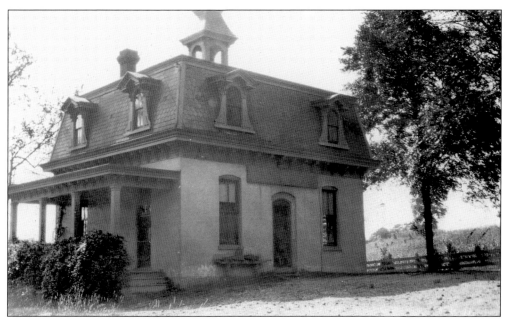

WHITAKER IRON COMPANY OFFICE, C. 1920. Built in the 1860s, this one-and-a-half story stucco building served as the office for the Whitaker Iron Company. It was also once used as a post office. Eight dormers and a cupola distinguish its mansard roof. The covered porch at left in this photograph has since been removed. (Courtesy of Historical Society of Cecil County.)

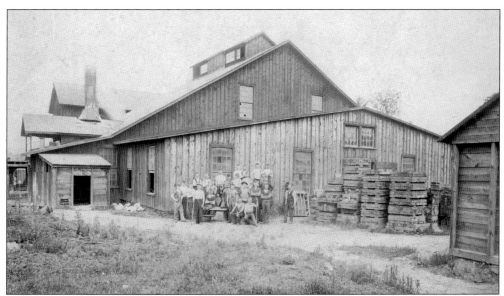

OWENS'S CANNING HOUSE. In the early years of the 1900s, Elmore Owens ran a steam-operated canning factory on the banks of a small stream aptly named Canning House Run. With a staff of 60, the cannery processed and canned local produce—mostly corn and tomatoes—under the River-Side Label. In the economy of that era, small local canneries were a common business. (Courtesy of Ray Keen.)

W.H. COLE'S STORE ON BROAD STREET, C. 1900. William H. Cole ran a store on Broad Street, located between Rodgers Tavern and the railroad crossing. The two-story wooden structure featured outdoor apparel such as rubber boots and rain gear, hunting and fishing goods, and groceries and hardware. (Courtesy of Wilma Denton.)

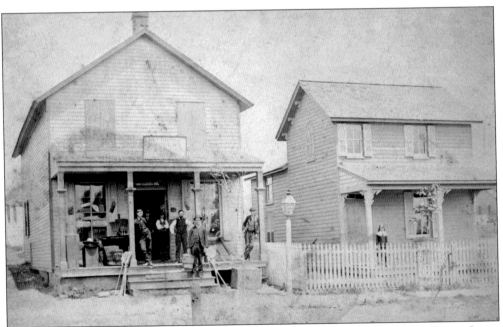

OWENS'S GENERAL STORE. In 1893, A.H. Owens & Son established a store on Front Street. Stores such as this were common in small towns everywhere. In 1994, 98-year-old Raymond Jackson recalled in an interview that became the basis of the small booklet *A. Raymond Jackson Recalls: Perryville, Maryland, 1900–1913* that as a child "groceries, meats and the check-out booth were to your left; in the back on both sides there were bananas, pickles in a barrel, oranges, pretzels, and an assortment of candies and gingersnaps." (Courtesy of Ray Keen.)

TAYLOR'S STORE, 1908. In Blythdale, several generations of the William Taylor family operated a general store from 1855 to 1950. It was also used as the Blythdale post office. Supposedly, oars from log rafts floated down the Susquehanna were used as the store's porch posts. (Courtesy of Historical Society of Cecil County.)

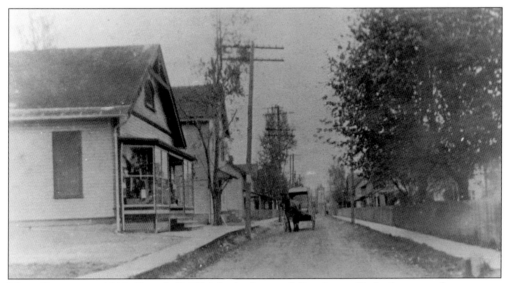

MILK DELIVERY, 1913. Joseph P. Wright is shown delivering milk by horse and wagon on Susquehanna Avenue. For years, Wright sold milk from his Richmond Hill farm throughout Perryville. Campbell's Store is visible at the front left of the photograph. (Courtesy of Historical Society of Cecil County.)

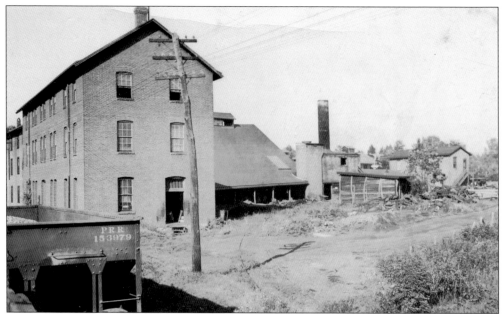

ARMSTRONG STOVE AND MANUFACTURING COMPANY OF PERRYVILLE AND BALTIMORE. Situated at the north end of Front Street and east of the railroad freight yard, this foundry manufactured wood and coal stoves. Once an important element of Perryville's economic structure, the advent of oil furnaces and electric or gas ranges led to the closing of the company in 1951. (Courtesy of Historical Society of Cecil County.)

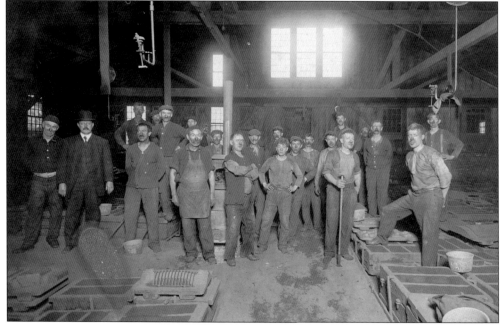

WORKERS AT THE ARMSTRONG STOVE COMPANY, C. 1910. A group of foundry workers poses in this interior view of the Armstrong Stove Company. The company employed pattern makers, core makers, and molders in the production of finished stoves. All employees were exposed to heat, smoke, dust, and molten metal. (Courtesy of Historical Society of Cecil County.)

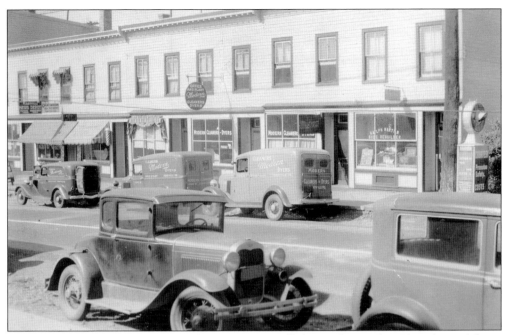

MODERN CLEANERS AND DYERS. In the 1930s, Perryville boasted a "modern" laundry and dying business on Broad Street. The success of the business is evident by the three delivery trucks parked in front of the store. A barbershop and the Perryville News Depot are visible to the left of the cleaners' storefront. (Courtesy of Historical Society of Cecil County.)

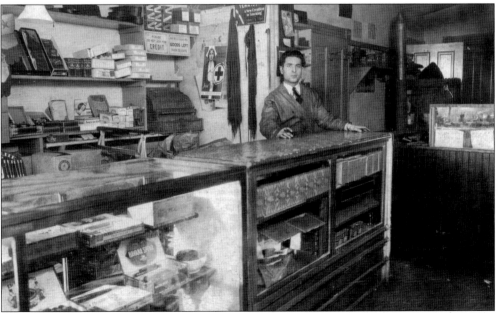

RALPH MARTINO'S SHOE REPAIR BUSINESS, 1935. Posing at the counter of his shoe repair shop on Broad Street, Ralph Martino was a member of Perryville's then-growing Italian American community. He ran a shoe repair shop in the row of businesses that occupied Broad Street at Boarding House Corner. Martino later owned and operated a package goods store on Aiken Avenue. (Courtesy of Rose Mary Boyd.)

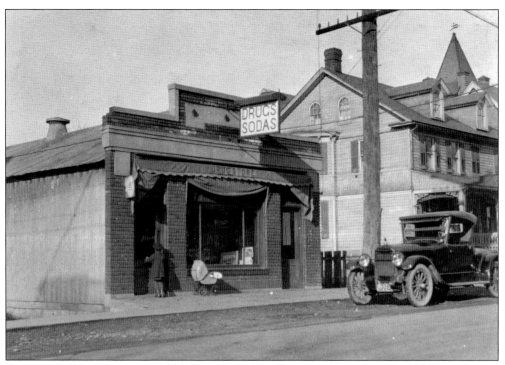

PLUMBLEY'S DRUG STORE, C. 1925. Plumbley's Drug Store was located on Broad Street. Despite the fancy brick facade and large picture window, a close look reveals the rest of the structure is crudely constructed of corrugated metal. The steeple of the Perryville Methodist Church can be seen at the upper right. (Courtesy of Historical Society of Cecil County.)

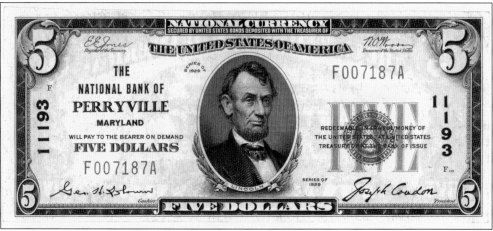

NATIONAL CURRENCY. Backed by bonds deposited with the treasurer of the United States, national currency was issued from 1863 to 1929 by banks chartered by the federal government. Over 14,000 banks issued these notes. The National Bank of Perryville issued this $5 note from the 1929 series. (Courtesy of the author.)

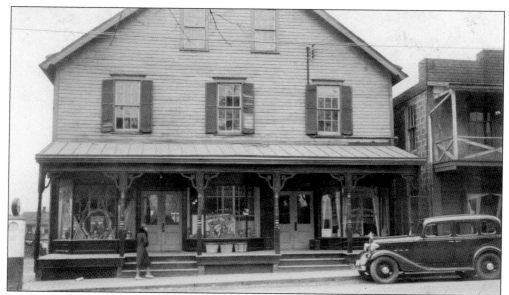

OWENS'S NEW STORE ON FRONT STREET, C. 1935. A.C. Jackson opened this store in 1901. He later sold the building to the Owens family, who moved their business from Front Street. The new, expanded location offered groceries and butchered meats on the first floor and hardware and dry goods on the second. (Courtesy of Historical Society of Cecil County.)

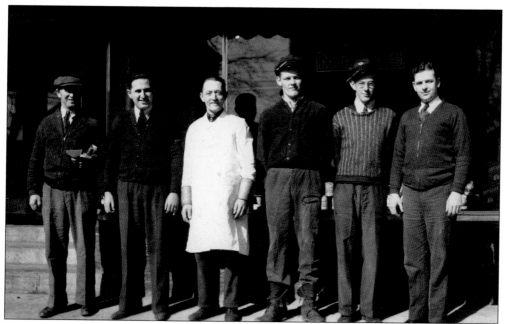

EMPLOYEES OF A.H. OWENS & SON, EARLY 1940s. The expanded business required a larger staff. This photograph was taken in front of the store. The employees pictured are identified as, from left to right, Bill J., Ham (Hanford Owens), Bones, Punk (John Bailey), Bill P., and Major. (Courtesy of Wilma Denton.)

LUIGI ALIGIA'S LIQUOR STORE. This photograph, taken in the late 1930s, shows the package goods store on Aiken Avenue owned by Luigi Aligia, which he opened soon after the repeal of Prohibition. Aligia sold the business to Ralph Martino in the 1950s. (Courtesy of Rose Mary Boyd.)

THE RENDEZVOUS INN, C. 1955. The Rendezvous, located on the corner of Front Street and Elm Street, has been a popular watering hole for many years. The tavern was originally owned and operated by Rodney Cole, but the building was first used as a butcher shop and a bakery. (Courtesy of Rendezvous Inn.)

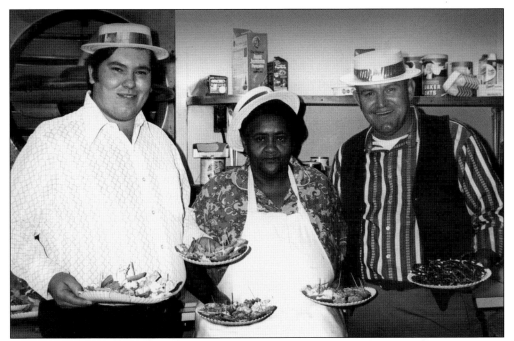

NEW OWNERS OPEN THE CECIL INN, FEBRUARY 1973. In February 1973, L.B. Guttmann, longtime Cecil Inn proprietor, sold his well-known Perryville tavern to new owners. Here, co-owner Woody Liddell (left), cook Hattie Jones (center), and co-owner Neal Fox celebrate the grand reopening of the inn. (Courtesy of the author.)

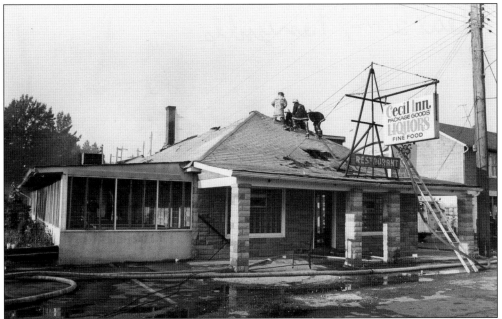

CECIL INN DESTROYED, 1977. Firefighters check the remains of the Cecil Inn after it caught fire in the early morning hours. The building was damaged beyond repair and was demolished. Jeffrey Fotiadis and Timothy Thompson later built the Island Inn on this site. (Courtesy of Historical Society of Cecil County.)

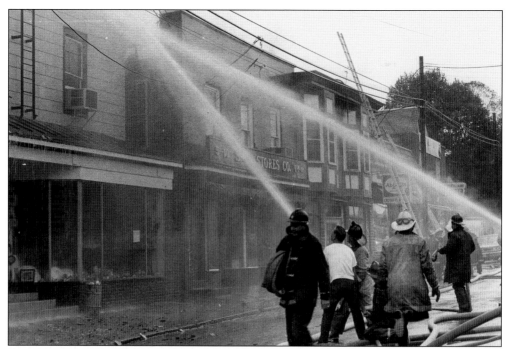

FIRE AT THE OLD A.C. JACKSON STORE. The old A.C. Jackson general store (later the Owens family store) was destroyed in a blaze on August 12, 1972. Owned by Irving Sadowski at the time, it was in use as an antique and used-furniture store. Next door, the S&S five-and-dime, also owned by Sadowski, was destroyed as well. Perry Villa Apartments were later located on this site. (Courtesy of Historical Society of Cecil County.)

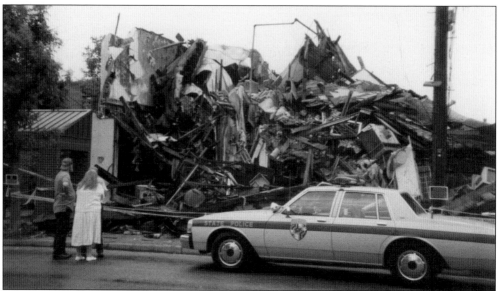

THE END OF AN ERA. At 8:55 a.m. on Saturday July 6, 1991, a gas explosion demolished the last vestiges of Perryville's downtown. Despite widespread damage, only one death was recorded. The Perryville Methodist Church and Perry Villa Apartments, on either side of the wreckage, suffered some damage but escaped relatively unscathed. (Courtesy of Charles Denton.)

Four

THE AGE OF THE AUTOMOBILE

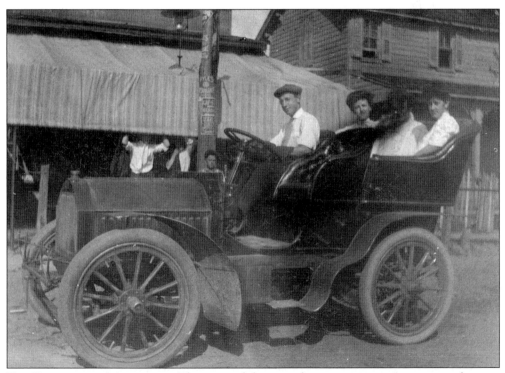

THE RISE OF THE AUTOMOBILE. The automobile was a fast-rising star in American culture in the early years of the 20th century. Here, a group poses in a touring car of that period in front of the A.H. Owens general store on Front Street, unaware of the vast changes the automobile would bring to life in Perryville, Cecil County, Maryland, and the entire country. (Courtesy of Wilma Denton.)

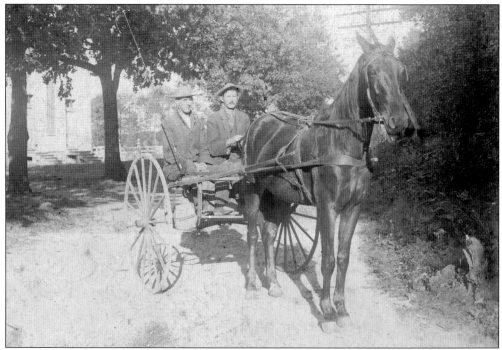

HORSE AND BUGGY IN CRAIGTOWN. C. Walton Taylor and John Ryan ride in a one-horse wagon, known as a gig, around the beginning of the 20th century. Travel by horse was the standard means of transportation at this time; the price of automobiles put cars beyond the means of the average person. (Courtesy of Historical Society of Cecil County.)

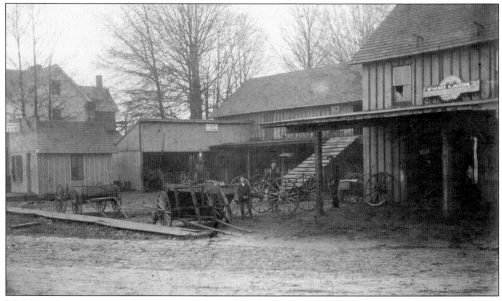

MCNAMEE AND JACKSON'S, C. 1900. Howard D. Jackson and Allie McNamee operated a livery stable, a blacksmith shop, and a wheelwright shop on the corner of Aiken Avenue and Broad Street. Before the arrival of the automobile, businesses such as this could be found in any small town, but automobiles rendered these concerns virtually obsolete. (Courtesy of Wilma Denton.)

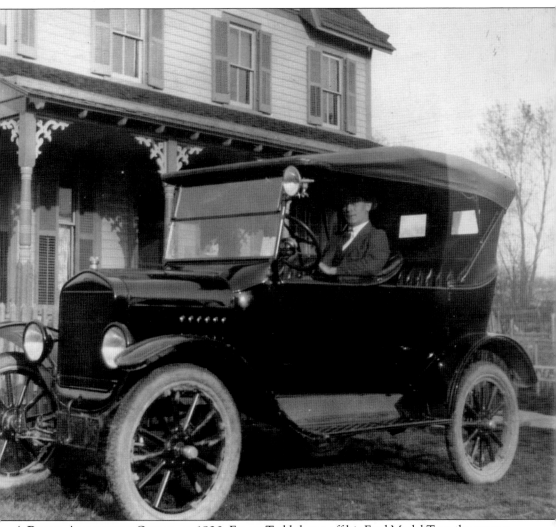

A Proud Automobile Owner, c. 1920. Ernest Todd shows off his Ford Model T on the corner of Otsego and Arch Streets. Henry Ford's assembly-line production techniques lowered the cost of automobiles so much that they were available to average Americans for the first time. (Courtesy of Historical Society of Cecil County.)

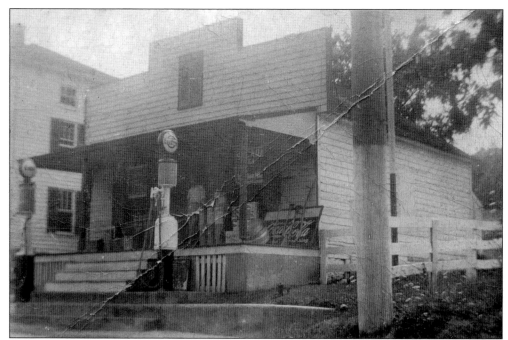

GASOLINE FOR SALE, C. 1935. William Taylor's store was in business for decades before the automobile burst upon the American landscape. By the time this photograph was taken, they had added gasoline to their sales inventory. Small family stores throughout the county responded to the growth of automobile use in similar fashion. (Courtesy of Historical Society of Cecil County.)

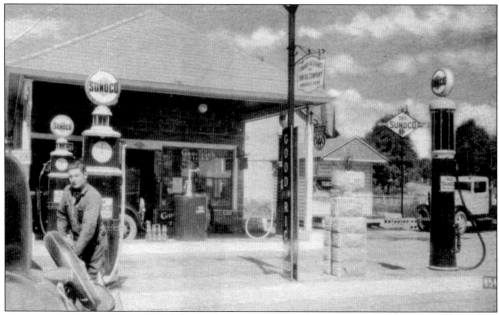

THOMPSON'S SUNOCO STATION. Willard Thompson's first garage was one of several service stations in Perryville that sprang up to accommodate the growing number of automobiles in town. In this photograph, owner Willard Thompson pumps gasoline for a customer, a service that is almost unheard of today. (Courtesy of Jim Hornberger.)

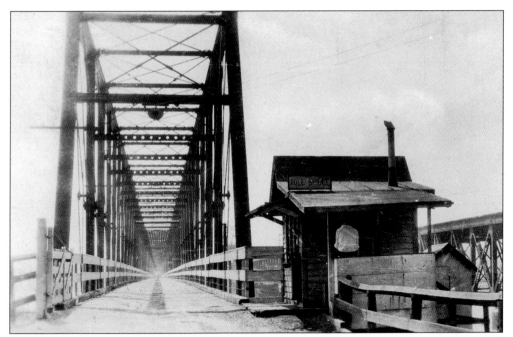

TOLL BRIDGE. In 1910, the old iron railroad bridge was sold to a group of private investors and converted to a toll bridge for vehicular use. At right is the wooden structure that served as the toll booth. The bridge proved so successful that it earned the nickname "the million-dollar bridge." The new railroad bridge can be seen at right. (Courtesy of the author.)

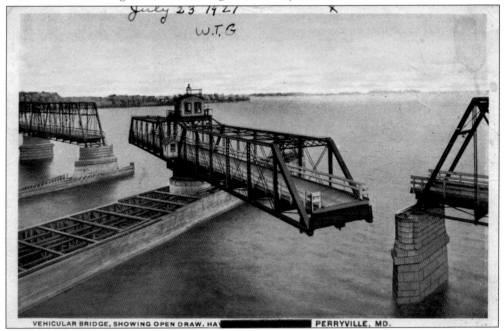

VEHICULAR BRIDGE, SHOWING OPEN DRAW. HA̲̅̅̅̅̅̅̅̅̅̅̅ PERRYVILLE, MD.

OPENING THE DRAW. This postcard, postmarked July 23, 1921, shows the toll bridge with its draw opening, which allowed larger vessels passage to upriver destinations. Maritime regulations require that bridges do not obstruct navigable waterways. The shoreline of Perry Point is visible in the background. (Courtesy of the author.)

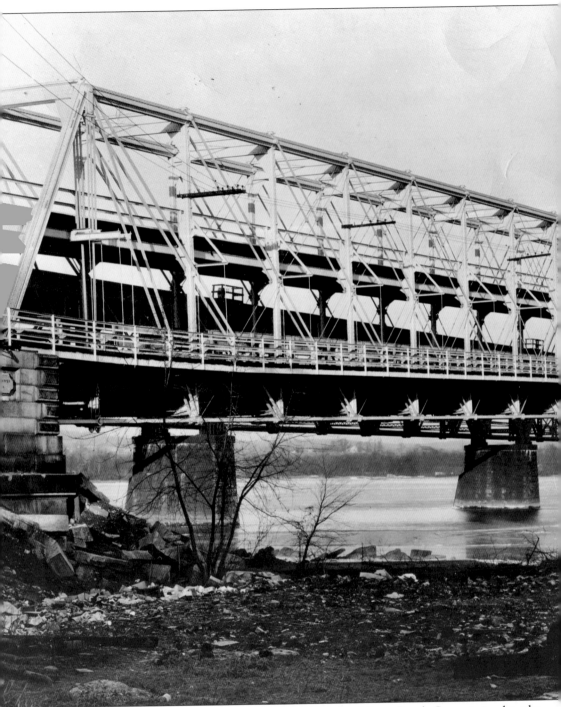

CONVERSION TO A DOUBLE-DECKER BRIDGE. The Maryland State Roads Commission bought the old Philadelphia, Wilmington & Baltimore Railroad Bridge, which had been converted to vehicular usage, for $585,000 in 1923 and converted it to a double-decked span in 1926. The conversion, made necessary by increased traffic and larger vehicles, was considered one of the most ingenious engineering accomplishments of the day. New approaches to the bridge led to a

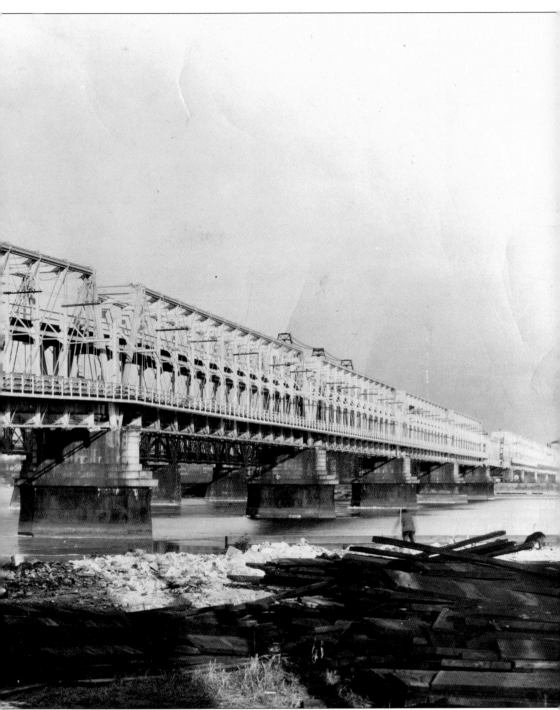

single lane of one-way traffic on each level; the lower deck accommodated westbound traffic, while eastbound traffic used the upper deck. Following the construction of the US Route 40 Bridge in 1940, the double-decker became expendable and was razed for scrap metal in 1943 in support of the war effort. (Courtesy of Historical Society of Cecil County.)

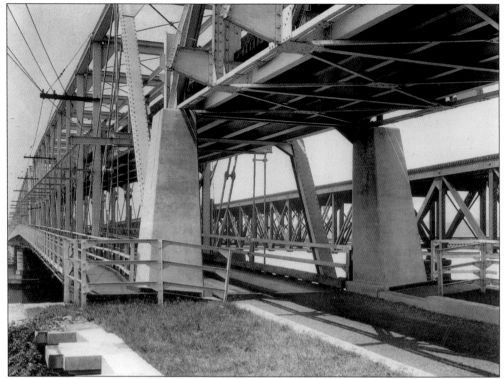

ENGINEERING OF THE DOUBLE-DECKER BRIDGE. This photograph shows a detailed view of the ingenious engineering required to convert the single-level bridge to a double-decked span. Concrete and metal structures support the new deck, located beneath the existing arches. A walkway for pedestrians was also added. (Courtesy of Historical Society of Cecil County.)

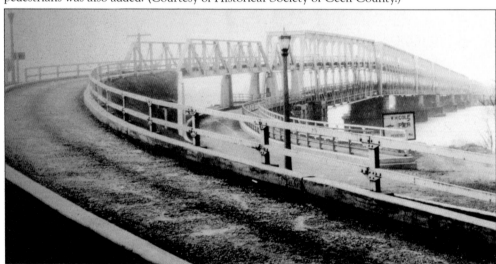

APPROACHES TO THE DOUBLE-DECKER BRIDGE. This photograph shows the new traffic pattern and approach that were necessitated by the addition of a second deck. Traffic traveling from Perryville used the lower deck, while eastbound traffic used the new upper deck. A sign advertising W.H. Cole's Pier, which was next to the bridge on the south, is visible beside the westbound lane. (Courtesy of Town of Perryville.)

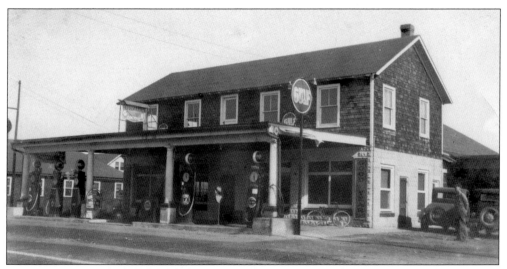

THE MCMULLEN BROTHERS' GARAGE IN THE 1930S. Located at the intersection of Broad Street and Aiken Avenue, McMullen's sold gas, serviced automobiles, and ran a Studebaker dealership. A business dedicated solely to the sale and servicing of automobiles was unheard of 30 years earlier. (Courtesy of Historical Society of Cecil County.)

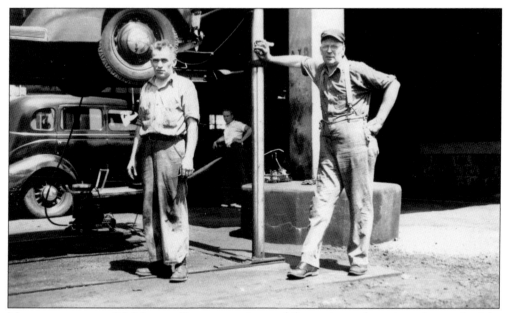

MECHANICS AT THE MCMULLEN BROTHERS. Automobile service and repair took over the jobs required to keep horses and wagons on the road. Employees who could perform tune-ups, hose and belt replacement, engine timing, and radiator repair replaced the blacksmiths, wheelwrights, and livery workers of not so long ago. (Courtesy of Wilma Denton.)

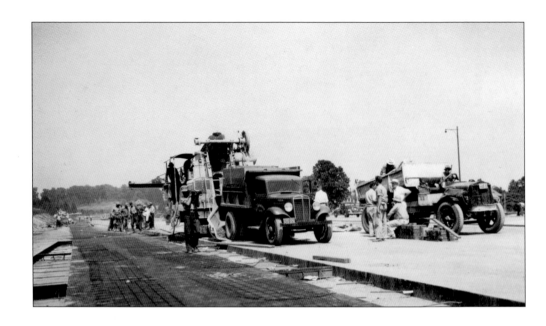

THE CONSTRUCTION OF US ROUTE 40. As the construction of the new US Route 40 neared Perryville, the scope of the project became apparent. These two photographs were taken on the stretch of Route 40 between Route 222 and the Susquehanna Toll Bridge. Today, it is easy to drive on Route 40 and forget the tremendous effort that went into its construction. (Both, courtesy of Historical Society of Cecil County.)

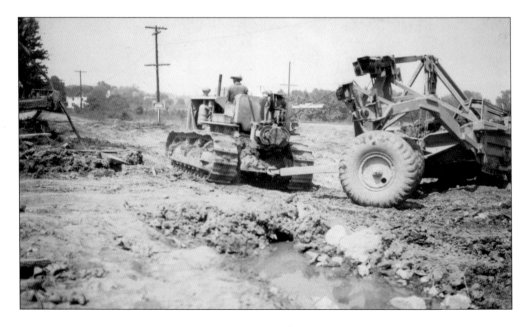

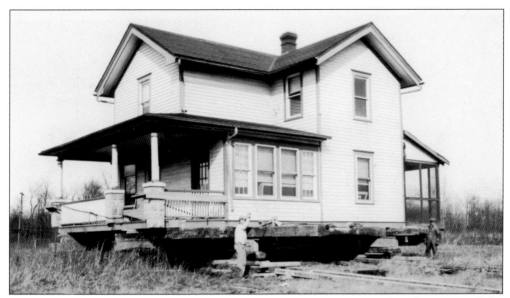

Moving Arthur Hornberger's House. As properties were acquired in the course of the construction of Route 40, some houses were demolished and others moved. Arthur Hornberger was the owner of Richmond Hill Farm; following the sale of his property, his house was moved to a new location. (Courtesy of Historical Society of Cecil County.)

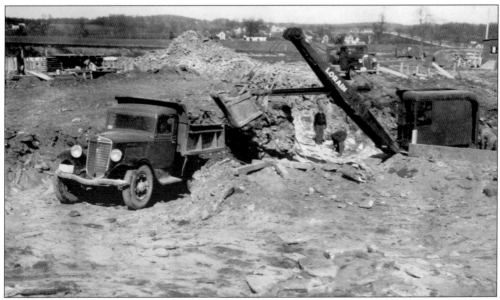

Construction of the Administration Building. The Susquehanna River Bridge's administration building and toll plaza were built on the Richmond Hill Farm property that once belonged to Arthur Hornberger. This photograph shows the site being prepared for the construction of the facilities. (Courtesy of Historical Society of Cecil County.)

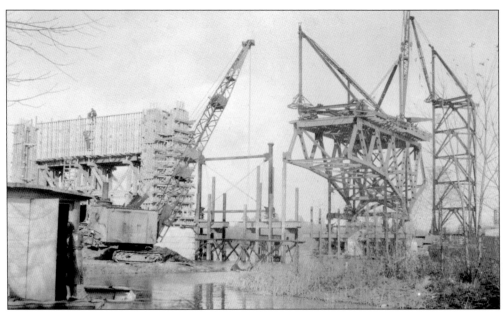

A NEW SUSQUEHANNA RIVER BRIDGE. Built to replace the obsolete double-decker bridge, construction of a new bridge for Route 40 started in February 1939. As work proceeded, the form of the bridge was revealed. Steel beams, stone block, and concrete pillars combined to produce an imposing new span. (Courtesy of Historical Society of Cecil County.)

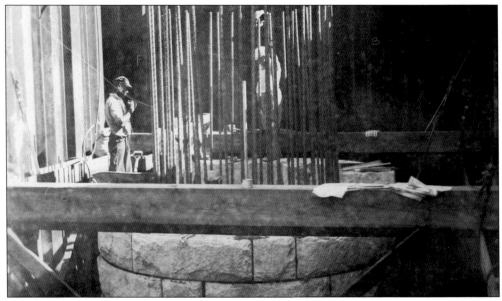

BRIDGE SUPPORT. Workmen secure reinforcement bars in the bridge's base. During the construction of the round stone bases for the bridge, rebar was set into place and concrete was poured into the hollow middle. Concrete columns to support the steel bridge structure would eventually rise from the stone bases. (Courtesy of Historical Society of Cecil County.)

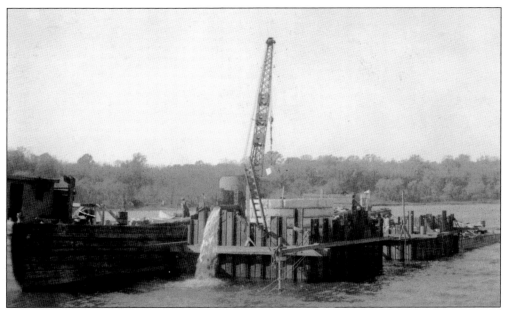

BRIDGE CONSTRUCTION BELOW WATER. As work on the bridge moved to the river, construction methods changed. Watertight caissons lowered to the river bottom allowed work to continue underwater. As water is pumped out of this caisson, stone pilings rise to hold concrete columns for the new bridge. (Courtesy of Historical Society of Cecil County.)

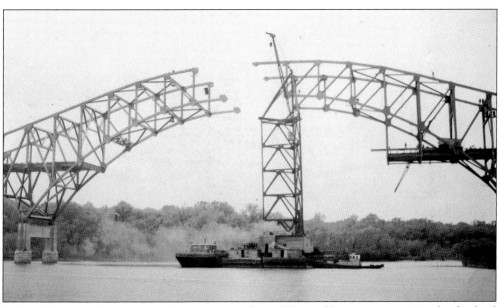

BRIDGE NEARING COMPLETION. A construction barge lifts steel beams into position for the final segments of the bridge's arch. The deck beneath the arch is yet to be completed. The bridge opened to traffic on August 28, 1940, and cost $4.5 million. The American Institute of Steel Construction bestowed its annual award of merit on the span, naming it "The Most Beautiful Steel Bridge of 1940." (Courtesy of Historical Society of Cecil County.)

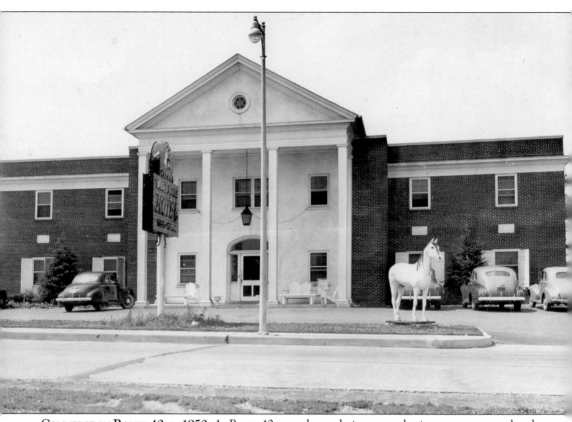

COMMERCE ON ROUTE 40, C. 1950. As Route 40 neared completion, many businessmen contemplated opening new enterprises or relocating existing businesses to take advantage of potential commerce on the new road. Cappy Croft built and operated the White Horse Hotel to accommodate travelers on the newly opened Route 40. It featured two bars and a kitchen, as well as a number of rooms for weary motorists. Note the statue of a large white horse that stood in the front of the property—this led locals to affectionately nickname the motel "The Pale Pony." (Courtesy of Historical Society of Cecil County.)

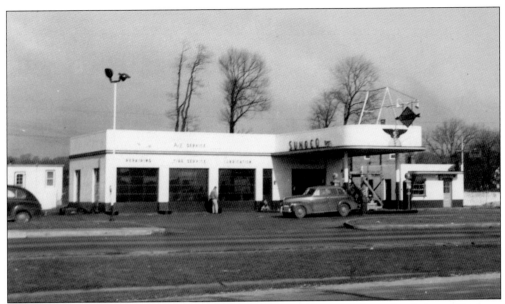

THOMPSON'S SERVICE STATION. The opening of Route 40 rerouted much of the traffic from Old Post Road and the commercial area of Perryville. Willard Thompson chose to relocate his service station to Route 40 to take advantage of the heavier traffic on the new road. (Courtesy of Jim Hornberger.)

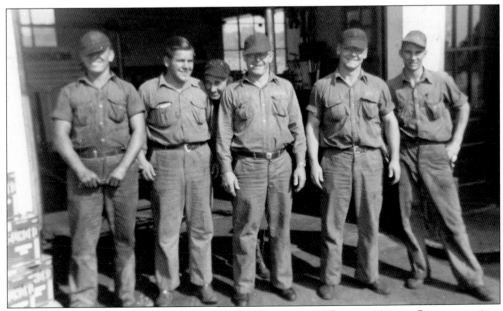

OPEN FOR BUSINESS. This was the first day of business at Thompson's new Sunoco station. Standing in line—and smiling in uniform—are, from left to right, George Chamberlain, James Hornberger, Bill Hall, owner Willard Thompson, Jess Thompson, and John Barrow. (Courtesy of Jim Hornberger.)

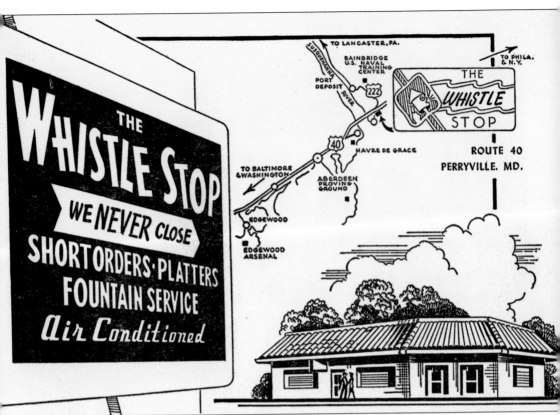

The Whistle Stop. The Whistle Stop was one of the new businesses along the new road. This advertisement for the restaurant, located at Aiken Avenue and US 40, noted that it was open 24 hours a day, seven days a week. Situated next to the old high school, it was a popular hangout for teenagers. In addition to the restaurant, the Whistle Stop also served as a stop on the Greyhound bus line. Crowds of sailors from the nearby Bainbridge Naval Training Center could often be found in the dining area, waiting for a bus. (Courtesy of Bill and Ellen Bradley.)

Five

FOR GOD AND COUNTRY

CAMP MEETING AT WOODLAWN, C. 1900. Arthur and Ella Owens and sons Clyde and Wilton pose behind their house on Otsego Street before departing for a camp meeting at Woodlawn. Originally adopted by the Presbyterians from Scottish traditions, Methodists also embraced camp meetings as part of their services. In the eastern United States, camp meetings were a signature of the denomination for decades. (Courtesy of Wilma Denton.)

PERRYVILLE PRESBYTERIAN CHURCH, C. 1900. Incorporated on October 10, 1888, Perryville Presbyterian Church was a modest wooden building. It is shown in its original location; in 1904, the PW&B Railroad purchased the land, and the church was moved to its current location on Broad Street. The railroad also gave the church $1,000 toward expenses incurred during the move. (Courtesy of Wilma Denton.)

PERRYVILLE BAPTIST CHURCH, C. 1940. Originally built in 1898 as a parish house for St. Mark's Episcopal Church, the Perryville Baptist Church began in 1957 as a mission of the First Baptist Church of Havre de Grace, Maryland. The church was constituted as a separate station in May 1974. (Courtesy of Historical Society of Cecil County.)

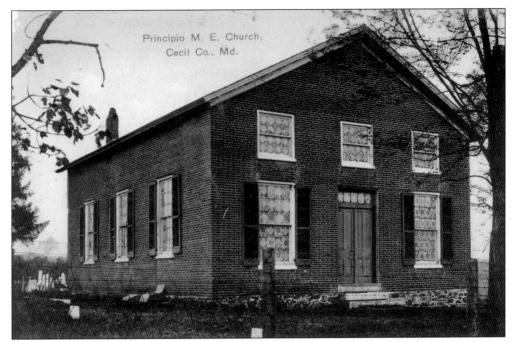

PRINCIPIO METHODIST EPISCOPAL CHURCH, 1908. This postcard shows the Principio Methodist Episcopal Church, built in 1845, prior to the installation of the stained glass windows it has today. With the exception of the windows, this sturdy brick church has remained virtually unchanged over the last 100 years. (Courtesy of the author.)

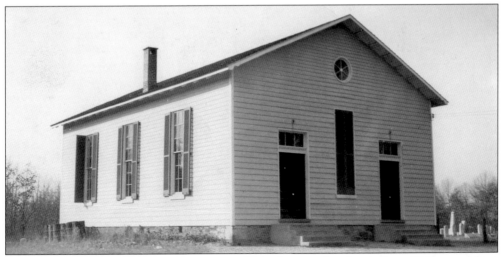

ASBURY METHODIST CHURCH AT CRAIGTOWN. This photograph, taken before a 1940 remodeling, shows the Asbury Methodist Church with its original clapboard siding. Built in 1859, the church was a simple wooden building. The remodeling included the additions of a brick exterior and stained glass windows. (Courtesy of Historical Society of Cecil County.)

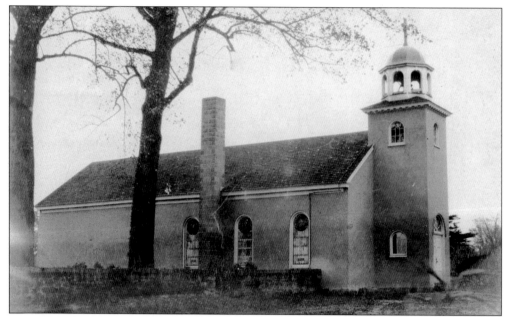

ST. MARK'S EPISCOPAL CHURCH, C. 1900. St. Mark's was built in 1844 as a chapel of ease to St. Mary Anne's Church in North East, Maryland. It was separated from St. Mary Anne's in 1913 and became the Susquehanna Parish. It has been enlarged three times over the years. This photograph was taken before wings were added on either side of the building. (Courtesy of Historical Society of Cecil County.)

BISHOP MOORE HONORED, 1978. In honor of Bishop W. Moultrie Moore of the Episcopal Diocese of Easton (comprised of the nine Eastern Shore counties), Dr. Joseph Coudon and his wife, Kate, hosted a tea at their home. Pictured here are, from left to right, Bishop Moore; his wife, Florence; Dr. Coudon; and his wife, Kate. (Courtesy of Historical Society of Cecil County.)

PERRYVILLE'S FIRST METHODIST CHURCH. This photograph from the late 1800s shows the first Methodist church in Perryville. Although the Methodists held services in Perryville beginning in 1866, this building was the congregation's first place of worship. Built in 1893, it served until the current stone church was built in 1896. It stood on the same site as the present-day church. (Courtesy of Historical Society of Cecil County.)

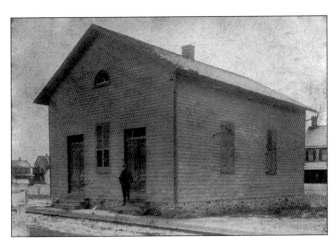

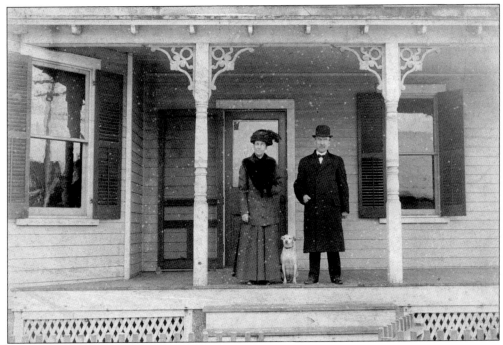

PERRYVILLE METHODIST PARSONAGE, c. 1910. Rev. and Mrs. E.C. Sunfield pose on the porch of the Methodist parsonage. Reverend Sunfield served as the minister to the Perryville Methodist congregation from 1909 to 1912. The parsonage has remained relatively unchanged. (Courtesy of Historical Society of Cecil County.)

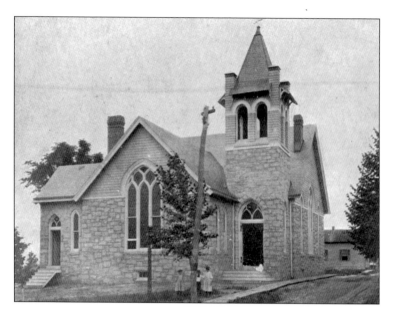

PERRYVILLE'S NEW METHODIST CHURCH. Dedicated on June 28, 1896, the new Methodist church was a stately building constructed of Port Deposit granite. In this photograph, the 1915 addition to the front of the structure, familiar to residents today, has not yet been built. (Courtesy of Historical Society of Cecil County.)

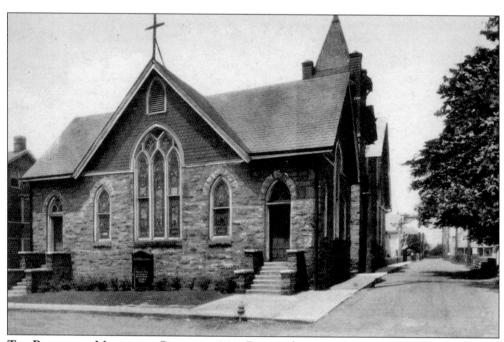

THE PERRYVILLE METHODIST CHURCH, 1940. Despite dramatic changes on this block of Broad Street after a series of fires and a devastating explosion directly next to the church, this sturdy granite church has remained virtually unchanged for many decades. (Courtesy of the author.)

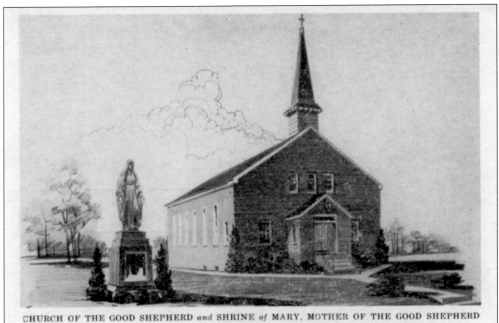

CHURCH OF THE GOOD SHEPHERD *and* SHRINE *of* MARY, MOTHER OF THE GOOD SHEPHERD
PERRYVILLE (Route 40) MARYLAND

CHURCH OF THE GOOD SHEPHERD. This postcard shows Perryville's Roman Catholic church—a simple, graceful brick building on Aiken Avenue—in the 1950s. The church started as a surplus US Army chapel at Aberdeen Proving Ground and was moved to its current site in 1949. (Courtesy of Historical Society of Cecil County.)

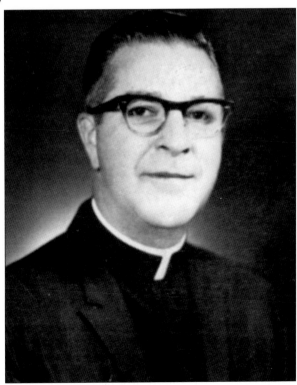

REV. WILLIAM R. COUMING. Father Couming served as the pastor of the Church of the Good Shepherd from 1950 to 1967. A well-loved figure in the Perryville community, he died on April 19, 1982. (Courtesy of Bill and Ellen Bradley.)

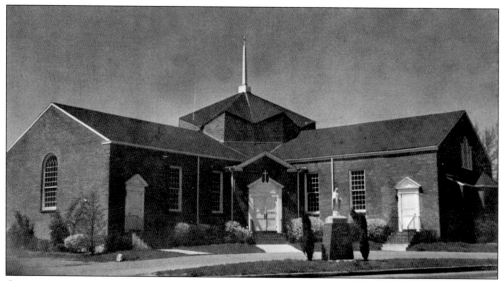

CHURCH OF THE GOOD SHEPHERD, 1972. In 1967, the church was remodeled, nearly doubling its size with the addition of a new wing. The statue of the Virgin Mary in front of the church was dedicated on May 23, 1954; it was a gift from Navy personnel stationed at nearby Bainbridge Naval Training Center. (Courtesy of Bill and Ellen Bradley.)

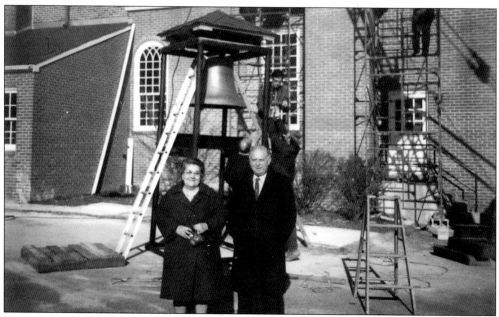

BELLS FOR GOOD SHEPHERD, 1974. To celebrate the 25th anniversary of the parish, members of the Church of the Good Shepherd joined forces to acquire two bells, refurbish them, and build a tower to house them—all at no cost to the church. Nannie and Ralph Martino, who paid for all materials used in the project, were photographed as the bells and tower were raised into place. (Courtesy of Rose Mary Boyd.)

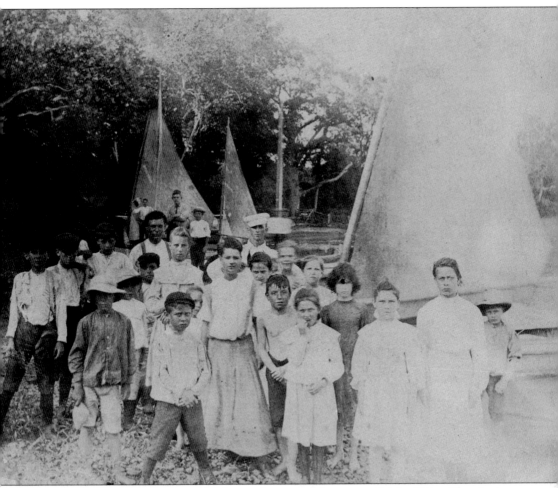

PICNIC AT SHIPLEY POINT, C. 1905. Children and young adults pose at Shipley Point. The picnic, sponsored by the Perryville Methodist Church, offered young folks a day of sailing, food, and fun at the beach. (Courtesy of Historical Society of Cecil County.)

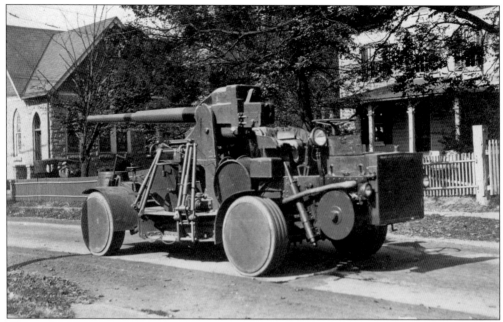

WORLD WAR I ARTILLERY IN PERRYVILLE. Perryville saw troops and equipment move through town during World War I. This photograph shows a piece of self-propelled artillery moving along Broad Street. The Methodist church is visible at left. (Courtesy of Wilma Denton.)

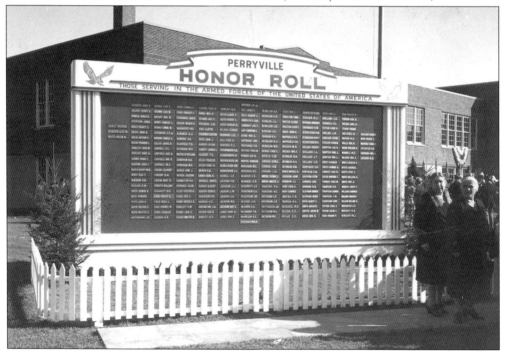

PERRYVILLE HONOR ROLL. On October 2, 1944, the citizens of Perryville dedicated an honor roll that listed all of the men and women of the area who were serving in World War II. The Honor Roll was placed in front of Perryville High School, where many of those listed had been enrolled as students only a short time before. (Courtesy of Jim Hornberger.)

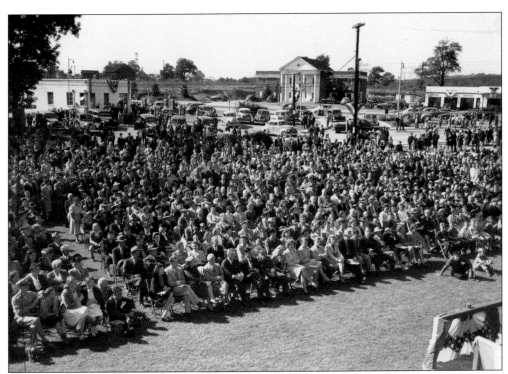

PERRYVILLE HONOR ROLL DEDICATION. A large crowd sat on the front lawn of Perryville High School for the dedication of the Honor Roll monument. Route 40, opened a few years earlier, is visible in the background, along with Cappy Croft's White Horse Hotel and Thompson's service station. (Courtesy of Jim Hornberger.)

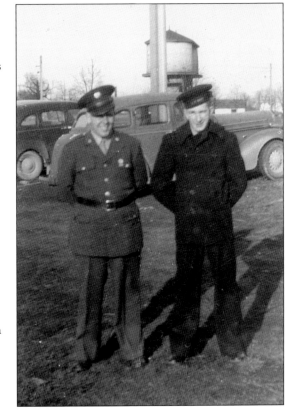

LEAVING FOR WORLD WAR II. This photograph, taken at the Perryville train station, shows lifelong friends Edwin Owens (left) and James Hornberger waiting to report for duty. Tragically, Owens was killed while serving his country. (Courtesy of Jim Hornberger.)

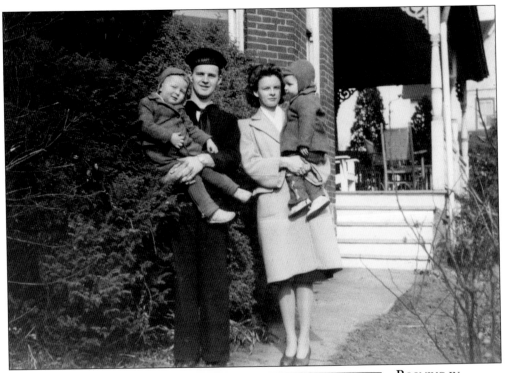

ROOMING IN PERRYVILLE. World War II brought on a severe housing shortage. In response, George and Margaret Bailey opened their home to servicemen and women in need of housing. This selfless spirit of patriotism and altruism was echoed in communities throughout the entire nation. In these photographs, a sailor with his family (above) and a soldier with a friend (left) pose at the Bailey home on Arch Street. (Both, courtesy of Wilma Denton.)

MEMORIAL DAY, 1950. In honor of the citizens of Perryville who gave their lives in battle, a monument was dedicated on May 30, 1950, at Perryville High School. On the granite memorial, a bronze plaque reads: "In honor of those of this precinct who served in World Wars I and II and in memory of," followed by a list of names of those who made the supreme sacrifice for their country. More names from later conflicts have been added over time. (Courtesy of Historical Society of Cecil County.)

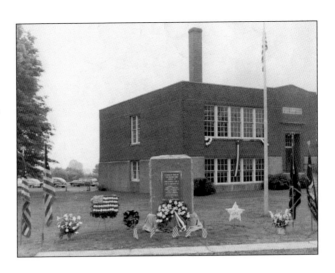

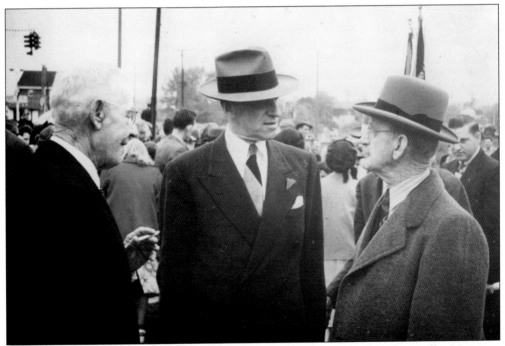

SEN. MILLARD TYDINGS. The War Memorial Committee, sponsored by Perryville American Legion Post No. 135, invited US senator Millard E. Tydings to speak at the dedication of the monument honoring Perryville's war dead. Here, Tydings (center) chats with Frank Walker (left) and William L. Taylor. Tydings represented Maryland in the US Senate from 1927 to 1951. (Courtesy of Historical Society of Cecil County.)

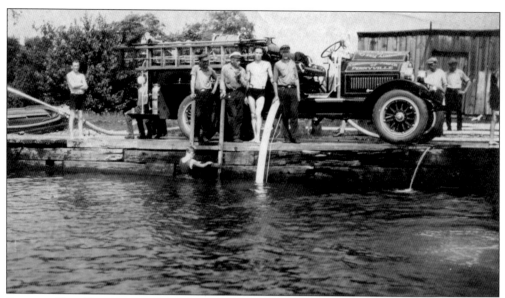

Filling a Fire Truck from the Susquehanna River. Firemen tap water from the Susquehanna, using hoses to fill their truck. The firemen share a Perryville wharf with swimmers. In simpler times, local youth were allowed to swim from almost any waterfront property in town—as long as they behaved. (Courtesy of Historical Society of Cecil County.)

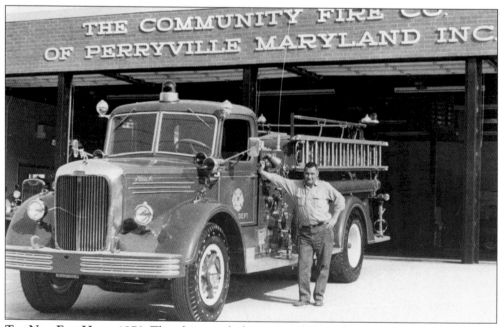

The New Fire Hall, 1970. This photograph shows one of Perryville's volunteer firefighters with Perryville's 1950s-era Mack fire truck in front of the new firehouse. Dedicated in November 1968, the new facility was a considerable upgrade from the old facility, which was built in 1926. It has since been enlarged several times. (Courtesy of Historical Society of Cecil County.)

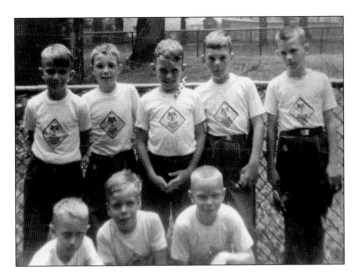

CUB SCOUT TRIP TO THE PHILADELPHIA ZOO. In the summer of 1955, Cub Scout Pack 144 took the train to visit the zoo in Philadelphia. The Cubs Scouts are, from left to right, (first row) Doug Hermann, Billy Preston, and Duffy Tipton; (second row) Alan Fox, Johnny Dishman, Woody Fadeley, Billy Bradley, and Terry Hornberger. A close look shows that Woody has a toy snake from the zoo's gift shop on his shoulder. (Courtesy of the author.)

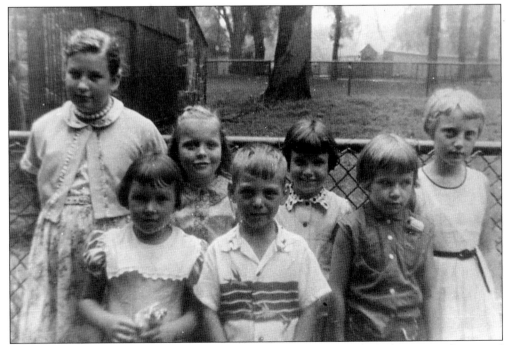

TRIP TO THE PHILADELPHIA ZOO. Relatives of the members of Cub Scout Pack 144 were also invited on the zoo trip. Pictured here are, from left to right, (first row) Joyce Fadeley, Jerry Bradley, and Linda Tipton; (second row) Linda Hornberger, Mary Sue Preston, Brenda Dishman, and Helen Hermann. (Courtesy of the author.)

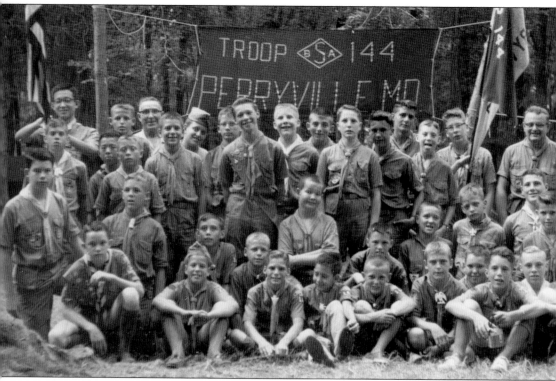

CAMP RODNEY BOY SCOUT RESERVATION. In continuous operation since 1923, the Camp Rodney Boy Scout Reservation is located on more than 900 acres of woodlands on the North East River and contains over a mile of gorgeous waterfront. In this 1963 photograph, Perryville Boy Scout Troop 144 poses at Camp Rodney. The annual visit to the camp was considered a highlight of a Scout's year. A wealth of outdoor and water-related activities gave Boy Scouts many opportunities to earn merit badges. (Courtesy of Gordon Roath.)

Six

SCHOOL AND SPORTS

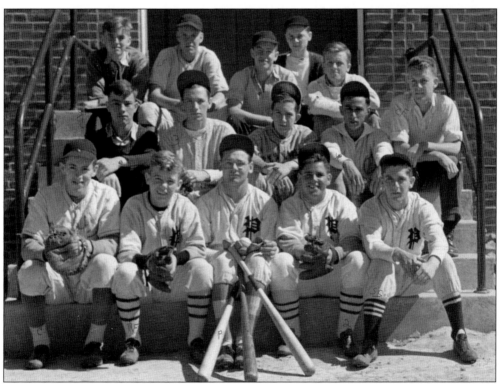

PERRYVILLE HIGH SCHOOL BASEBALL TEAM, 1937. Perryville's 1937 baseball team poses on the back steps of the school. Despite the hardships imposed by the Great Depression, life went on as normally as could be expected, although the diversity of uniforms worn by the players may reflect the hard times. The players are, from left to right, (front row) Raymond McNeil, Everett Bailey, Jess Thompson, James "Onions" Hornberger, and Jim Calao; (second row) Vernon Enington, Carl Wheeler, Edward Owens, Tom DiAngelo, and Jack Robinson; (third row) Roger Reynolds, Roland "Cots" Preston, Dotson Hawley, Thomas Owens, and George Hornbarger. (Courtesy of Jim Hornberger.)

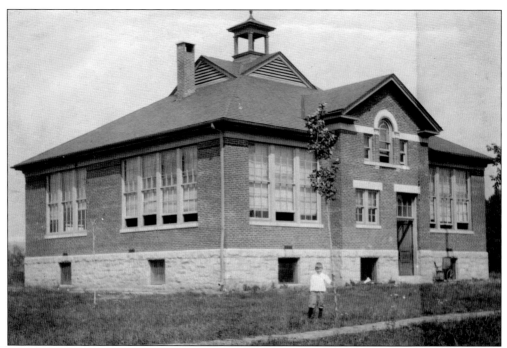

NEW PUBLIC SCHOOL BUILDING ON CHERRY STREET. The old Perryville Public School, which replaced the wooden school building on Susquehanna Avenue around 1900, was originally a one-story structure. At the time of this photograph, all grades were taught in the same building. The young boy standing in front of the school is Walter Gillespie. (Courtesy of Historical Society of Cecil County.)

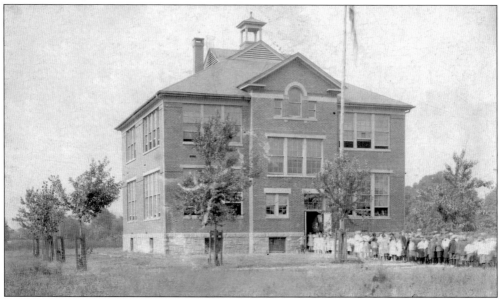

PERRYVILLE PUBLIC SCHOOL C. 1910. As Perryville grew, the school needed to accommodate a growing number of students. This was accomplished at Perryville Elementary by simply constructing a second story on the existing one-story structure. More enlargements were added in later years. (Courtesy of Bill and Ellen Bradley.)

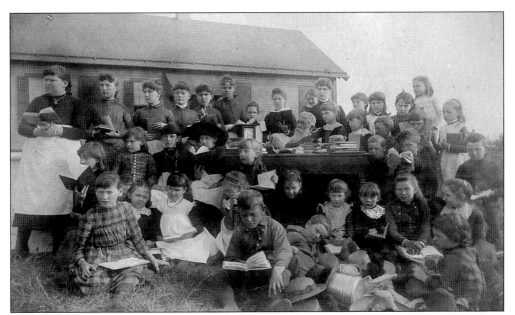

SCHOOL ON SUSQUEHANNA AVENUE, C. 1890. Samuel J. Tammony, seated behind the desk, poses with pupils outside the public school at 524 Susquehanna Avenue. After the new public school building opened on Cherry Street, the building served as the Perryville Mechanics Hall and later as the home for Perryville American Legion Post 135. (Courtesy of Historical Society of Cecil County.)

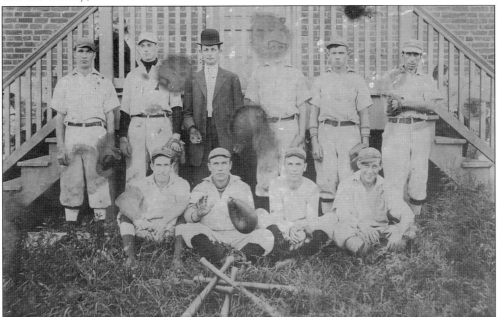

PERRYVILLE BASEBALL TEAM, C. 1910. An early photograph shows a Perryville baseball team posing outside of the side entrance of the old elementary school on Cherry Street. Intercounty play was popular, and H.D. Jackson's Livery, located on Aiken Avenue, built a special wagon for Perryville's Cecil County League team to travel on. Drawn by a two-horse team, it featured a compartment for baseball equipment below the seats. (Courtesy of Terry Hornberger.)

BLYTHEDALE PUBLIC SCHOOL, C. 1900. Until it closed in 1911, Blythdale Public School was housed in this two-room wooden schoolhouse. As consolidated schools were built, small schools closed throughout the county. The Household of Faith Church is visible in the background at left. (Courtesy of Historical Society of Cecil County.)

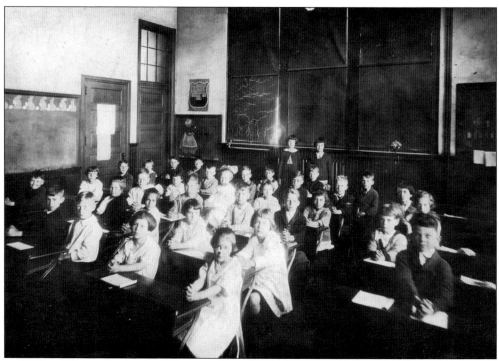

PERRYVILLE ELEMENTARY SCHOOL INTERIOR, 1920. The classrooms of this period were far different from the classrooms of today. Students, seated two to a desk, face an austere classroom outfitted with only the bare necessities of teaching. This reflects a no-nonsense approach to education that was typical of the period. (Courtesy of Rose Mary Boyd.)

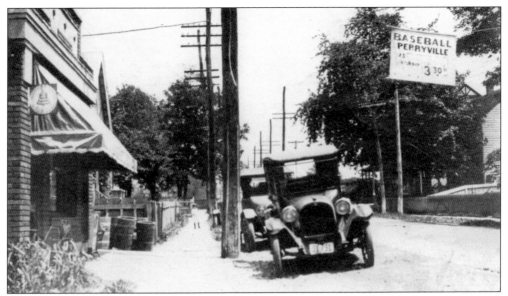

BASEBALL IN PERRYVILLE, C. 1925. A banner strung over Broad Street in front of Plumbley's Drug Store proclaims that there will be "Baseball in Perryville" on Saturday at 3:30. Perryville shared the nation's mania for the national pastime and for decades fielded teams of quality amateur and semi-professional baseball players. (Courtesy of Historical Society of Cecil County.)

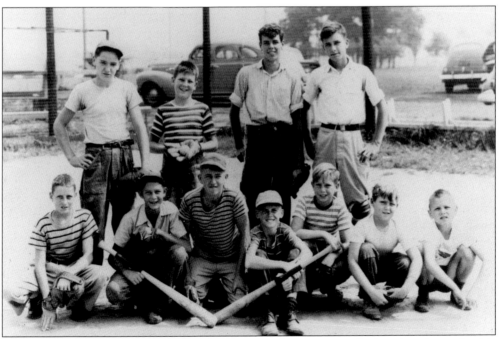

SANDLOT BASEBALL, C. 1946. A pickup game was always easy to find, and as shown in this photograph, age was never an important factor when getting players together for a game. Pictured here are, from left to right, (first row) Marvin Todd, Barney Biddle, Danny Meck, Jerry Calvert, Donny Cole, Billy Cole, and George Chamberlain; (second row) Jimmy Faer, Butch Thompson, Darwin Evans, and Mike Hasson. (Courtesy of Jim Hornberger.)

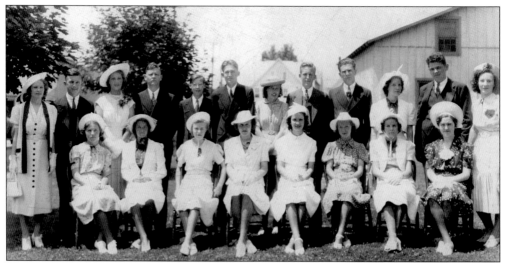

PERRYVILLE HIGH SCHOOL GRADUATION. The class of 1938 poses for a traditional graduation picture. The graduates are, from left to right, (first row) unidentified, Virginia Watson, Anna Morrison, Augusta Smith, Anna Myrtle Anderson, Adele Owens, Mary Schroder, and Margaret Hornbarger; (second row) Ruth Carson, Leslie "Ting" Owens, Lydia Warrington, Martin Carson, Myron Wright, Lloyd Roberts, Gladys Michael, unidentified, Bill Weaver, Elizabeth Schroder, George Fotiadis, and Ruth Edditon. (Courtesy of Margaret Hornbarger Cifaldo.)

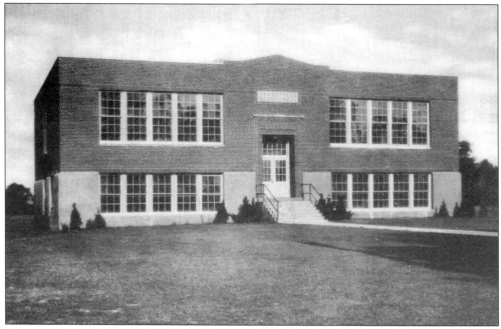

PERRYVILLE HIGH SCHOOL, 1940. In 1929, a new high school was built on Aiken Avenue. When this picture was taken, the school was unchanged from its original form. Several subsequent additions added classrooms, shops, and a multiuse auditorium/gymnasium/theater space to the school. A major addition was constructed on the back of the building in 1960, doubling the space. (Courtesy of the author.)

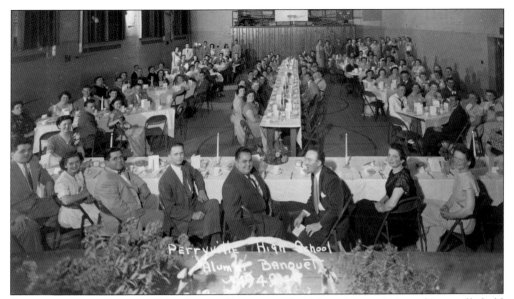

PERRYVILLE HIGH SCHOOL 1949 ALUMNI BANQUET. The Alumni Association of Perryville held an annual banquet and dance open to all Perryville High graduates. In 1949, the banquet was held in the Perryville High School auditorium. Because of the growing number of graduates, this tradition was discontinued in the mid-1970s. (Courtesy of Jim Hornberger.)

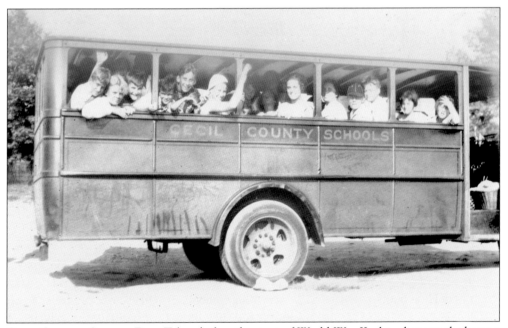

CECIL COUNTY SCHOOL BUS. Taken before the start of World War II, this photograph shows a school bus of the prewar era. Open windows and overcrowding were of no concern. (Courtesy of Wilma Denton.)

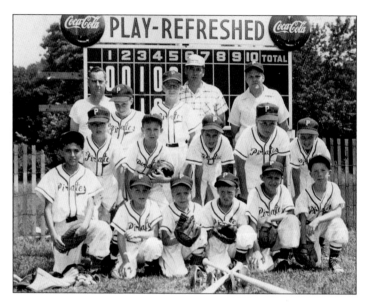

PERRYVILLE LITTLE LEAGUE, 1955. This was the first year of Little League play in Perryville. After tryouts, players were divided into two sections—the majors and the minors. This team, the Pirates, won the inaugural major division championship. (Courtesy of Jim Hornberger.)

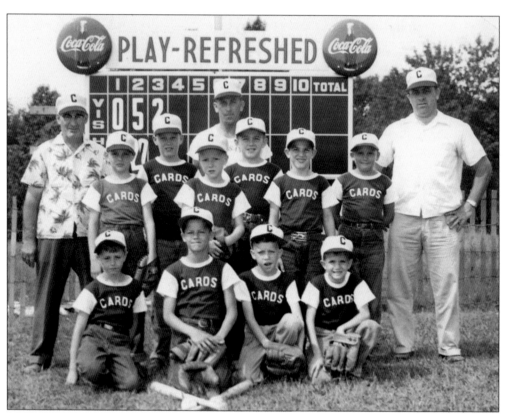

MINOR-DIVISION CARDINALS. All Perryville Little League games in 1955, for both the major and minor divisions, were played at the Perryville Elementary School field or on fields at Perry Point. Unlike the major division, the minor division players did not have full baseball uniforms—just jerseys and hats. (Courtesy of Jim Hornberger.)

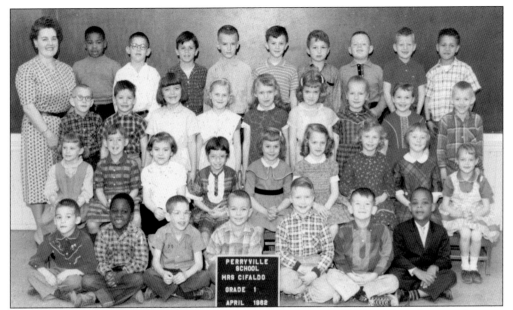

MARGARET CIFALDO'S FIRST-GRADE CLASS, 1962. By the early 1960s, a class photograph was a yearly event for students at Perryville Elementary School. Here, scrubbed, combed, and nicely dressed, Cifaldo's first-grade class smiles for the photographer. Cifaldo taught at Perryville Elementary School for many years. (Courtesy of the author.)

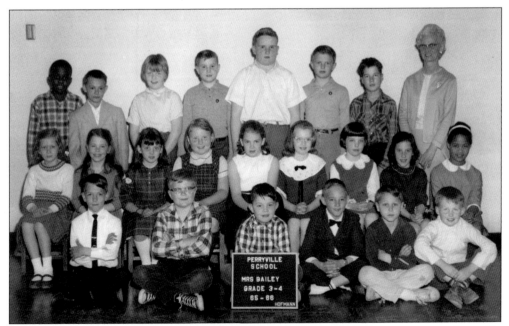

MARGARET BAILEY'S CLASS, 1965–1966. Margaret Bailey, who taught for many years at Perryville Elementary School, had a mixed group of third- and fourth-graders as her class from 1965 to 1966. While individual school photographs had been taken for many years, class photographs became available at Perryville in the 1960s. (Courtesy of the author.)

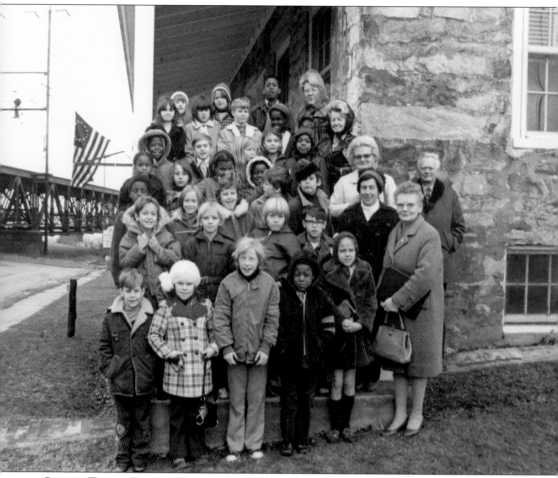

SCHOOL TRIP TO RODGERS TAVERN. Rodgers Tavern has long been popular among teachers as an American history field trip. Colonial lifestyles, the American Revolution, and historic presidents and the Founding Fathers are among the many topics that could be discussed after a trip to the tavern. In this photograph, Mrs. Howes (far right, front row), chaperones, and Howes's third-grade class from Elkton Elementary School in Elkton, Maryland, pose for a souvenir photograph during a February 1973 visit. (Courtesy of Historical Society of Cecil County.)

Seven

AROUND THE TOWN

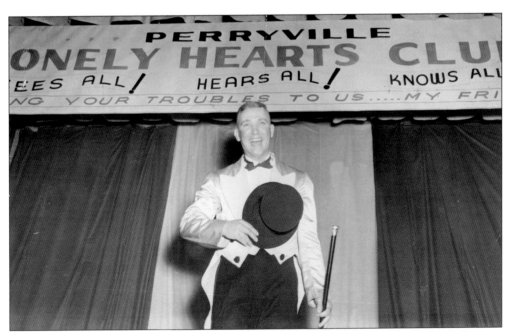

THE PERRYVILLE LONELY HEARTS CLUB, C. 1950. Smiling broadly in top hat and tails, Roscoe "Rock" Ryan serves as the master of ceremonies at a variety show held in the auditorium of the Perryville High School. Before television, shows such as this featuring well-known locals were an entertainment staple in small towns. (Courtesy of Jim Hornberger.)

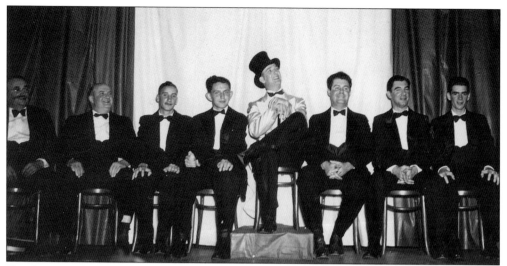

THE LONELY HEARTS CLUB PLAYERS. Roscoe Ryan (center, wearing top hat) holds court with a tuxedoed troupe of Lonely Hearts Club players. Pictured here are, from left to right, Herb Williams, Wilton Owens, Norval Sinclair, Bobby Keen, Ryan, Benny Boyd, Eddie Krummel, and Marion Todd. (Courtesy of Jim Hornberger.)

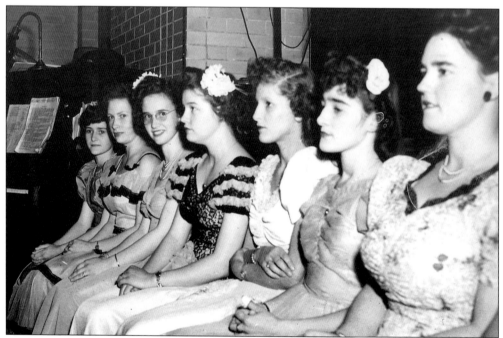

THE LONELY HEARTS CLUB LADIES. The female variety show performers wait backstage to take their turns. Pictured here in gowns and stage makeup, they are, from left to right, Mildred Walker, Elaine White, Katherine Benedict, Jane Bailey, Irene Moore, Lois Jackson White, and Margaret Hornbarger Cifaldo. (Courtesy of Jim Hornberger.)

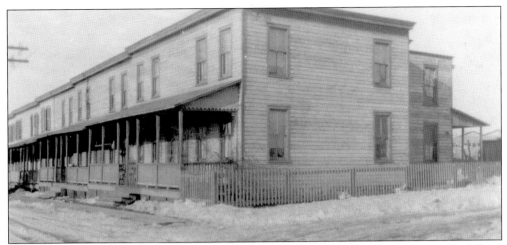

SCAB ROW, C. 1930. This 10-unit row house on Susquehanna Avenue was known as Scab Row. It was built around 1900 to house laborers brought in by the railroad to work during a strike. The unit was dubbed "Scab Row" by angry citizens, many of who depended on the railroad for their livelihoods. (Courtesy of Wilma Denton.)

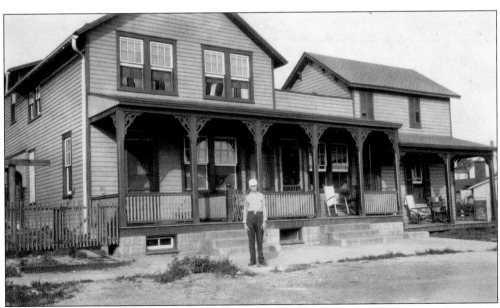

RENTAL HOUSES ON FRONT STREET, C. 1935. When the A.H. Owens & Son general store (on Front Street) was relocated to A.C. Jackson's building on Broad Street, the old store and adjacent house were connected by a new third structure and converted to rental housing. (Courtesy of Historical Society of Cecil County.)

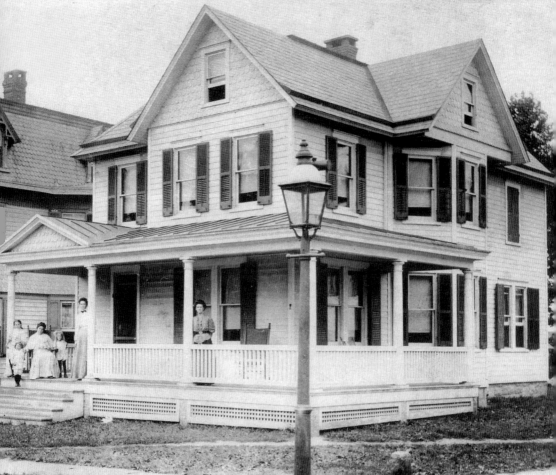

THE WILLIS B. GORRELL HOME. This 1909 photograph shows the home of Willis B. Gorrell. As noted on the photograph, Gorrell served as mayor of Perryville from 1948 to 1956. Dating from 1900, the house sits on the corner of Elm Street and Susquehanna Avenue. Well built and maintained over the years, it stands as a testament to the quality of the workmanship and materials of the early 20th century. (Courtesy of Bill Bailey.)

THE PERRYVILLE POST OFFICE. Located on Broad Street next to A.C. Jackson's store, this small structure served as the post office for Perryville. The building later served as an office for Benjamin L. Cole, the local magistrate. It the 1950s, it was moved to make room for the local branch of the First National Bank of Maryland. (Courtesy of Historical Society of Cecil County.)

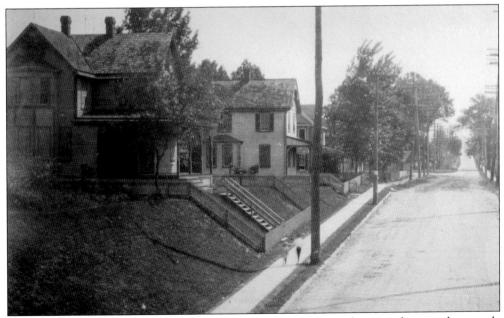

BROAD STREET, LOOKING EAST, C. 1910. This photograph shows the steep downward cut made by the railroad to allow traffic to travel under two new bridges over Broadway (now known as Broad Street). The empty lot at left became the site for the firehouse, built in 1926. (Courtesy of Historical Society of Cecil County.)

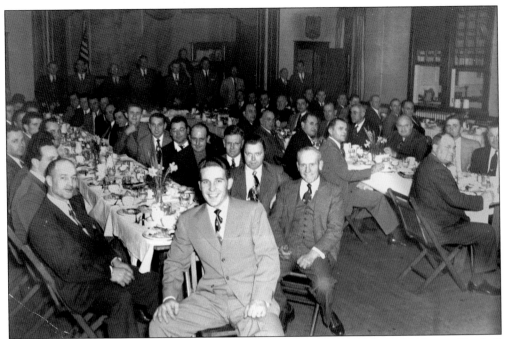

THE SUSQUEHANNA BASEBALL LEAGUE AWARDS BANQUET. Members of the Susquehanna Baseball League gather in the second floor of the Perryville Fire Hall in this 1940s photograph. The second floor had a stage area, a large open floor, and a well-equipped kitchen. It served as a banquet, dance, and bingo hall, as well as a meeting room and was used by many local clubs and groups. (Courtesy of Jim Hornberger.)

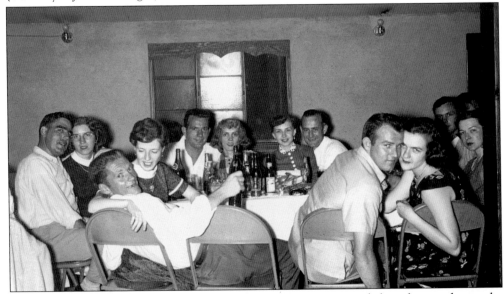

A NIGHT OUT AT POST NO. 135, 1954. A group of young men and their dates gather at the Perryville American Legion Hall to enjoy some jukebox music and a cold drink with friends. This generation grew up during the hard times of the Depression and came of age during the horrors of World War II and the Korean War. The 1950s were a welcome decade of peace and prosperity. (Courtesy of Sandra Johnson.)

A.C. Jackson's House. Andrew C. Jackson owned and operated a store on Broad Street in the early 20th century. Opened in 1901, it was later sold to the Owens family, who relocated their store from Front Street. Jackson's prosperity is reflected in his landscaped Victorian house enclosed by a white picket fence. (Courtesy of Wilma Denton.)

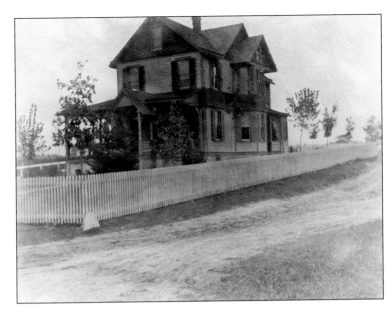

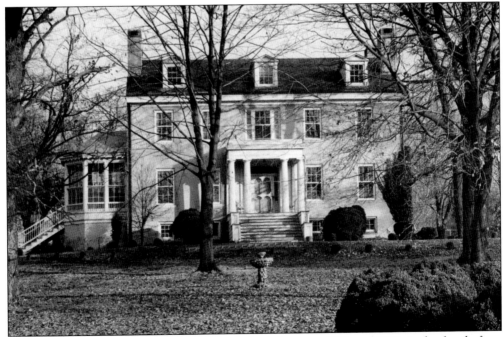

Joseph Coudon's Home, 1974. Woodlands, built between 1812 and 1814, is the family farm and home of the Coudon family. One of the oldest dwellings in the Perryville area, it contains hardware stamped with the initials "WR" (for King William IV of England). (Courtesy of Historical Society of Cecil County.)

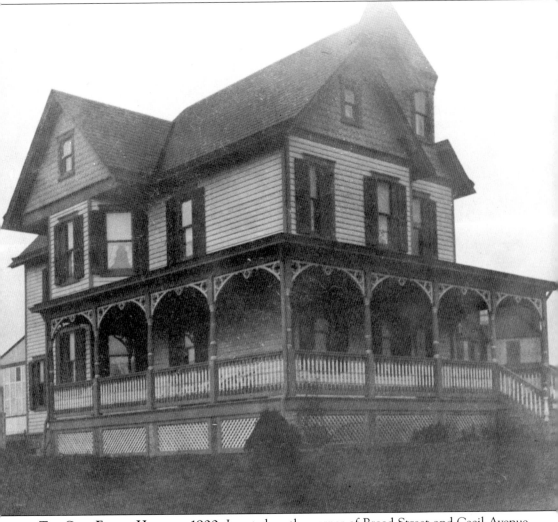

THE COLE FAMILY HOME, C. 1900. Located on the corner of Broad Street and Cecil Avenue, this building was home to generations of the Cole family and is one of the finer old houses in Perryville. A grand example of Victorian architecture, it features a turret, a wraparound porch, and gingerbread. An entrepreneurial family, the Coles ran a general store and a business on the Susquehanna that bought and sold fish and game, and they held a variety of interests in many other endeavors in town. (Courtesy of Wilma Denton.)

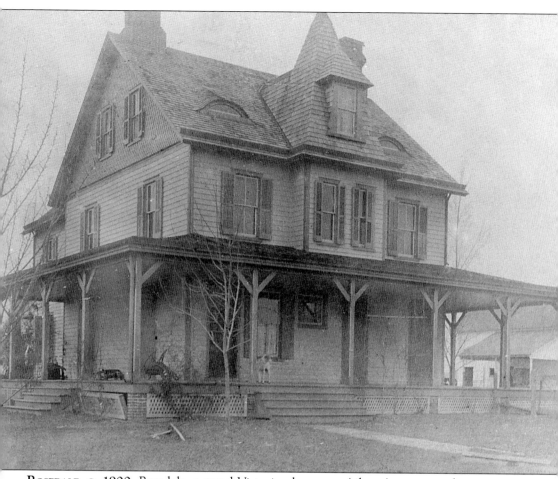

ROSEDALE, C. 1900. Rosedale, a grand Victorian house on Aiken Avenue, was home to two prominent Perryville physicians—Dr. and Mrs. George M. Stump lived in the house until his death in May 1925, and Dr. and Mrs. James F. McGraw lived in the house after the Stumps. In the early 20th century, it was common for a small-town physician to run his practice out of his home. Patients were seen in a room that served as an office or on a house call—which was then a routine part of a doctor's business day. (Courtesy of Wilma Denton.)

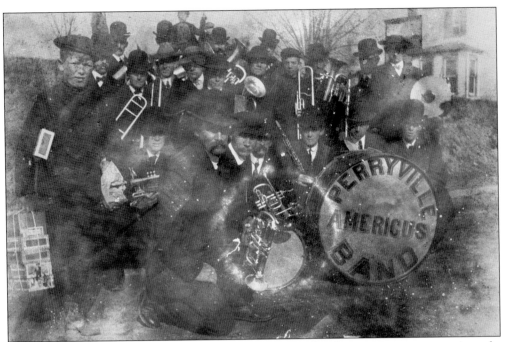

PERRYVILLE AMERICUS BAND, 1905. A community brass band was a common extension of a town's civic pride in the early years of the 20th century. Here, the Perryville Americus Band poses on Broad Street. The home of Mr. and Mrs. Frank H. Nickle is visible in the background. The Perryville Fire Company was later built on the empty lot shown behind the band. (Courtesy of Historical Society of Cecil County.)

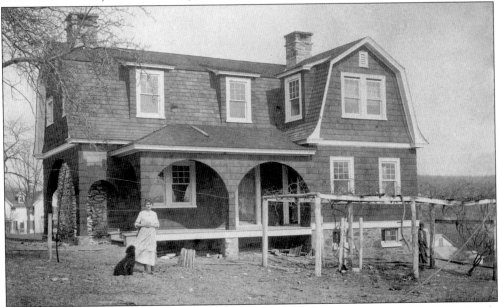

HENRY C. BURROUGHS HOME, C. 1920. Mrs. Henry Burroughs, standing outside of the family homestead, and her husband lived in one of the older Perryville homes. Expensively altered, this house in the Blythedale neighborhood contains the logs of the original timber structure. (Courtesy of Historical Society of Cecil County.)

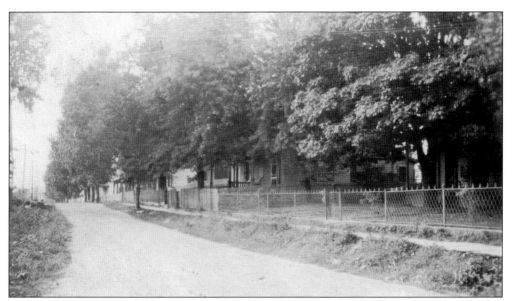

FRONT STREET, LOOKING NORTH, C. 1910. In the early years of the 20th century, Front Street was a tree-lined dirt road. This was typical in many small Maryland towns at the time. Amenities such as municipal water and sewage—and paved roads and sidewalks—were slow in coming to many small towns. (Courtesy of Historical Society of Cecil County.)

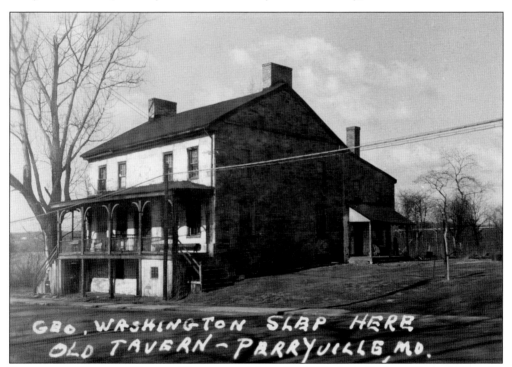

POSTCARD OF RODGERS TAVERN. This postcard from the 1940s shows Rodgers Tavern before the 1950s restoration by the Friends of Rodgers Tavern. Owned by the Pennsylvania Railroad, it was rented as a two-family dwelling. Note the creative spelling of the word "slept" on the postcard. (Courtesy of the author.)

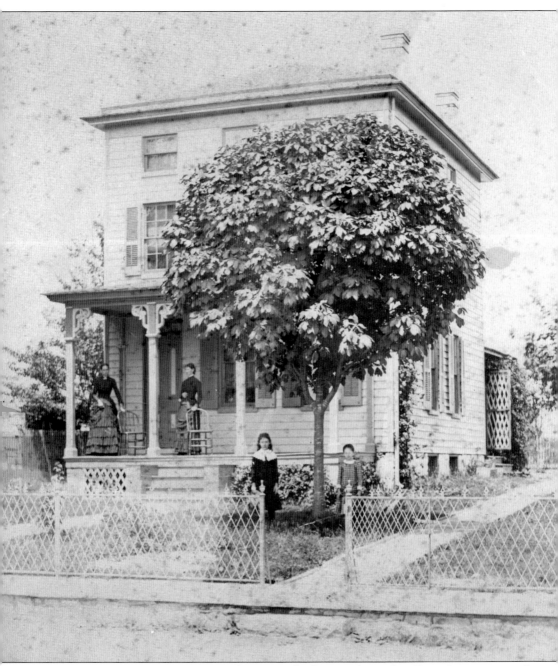

ELMORE OWENS HOUSE, C. 1895. Built in 1869, this house is located on Front Street, next to the former location of A.H. Owens & Son's general store. It is believed that the foundation of the building came from a house that formerly stood on the site. The house is a modified example of the Italianate architecture that was very popular in late-19th-century America. Elmore Owens was a prominent Perryville businessman who was involved in many successful ventures during this time. The people in the photograph are unidentified. (Courtesy of Ray Keen.)

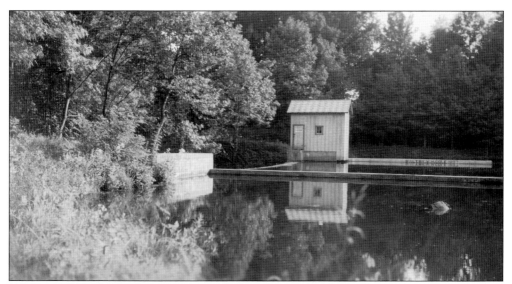

THE PERRYVILLE RESERVOIR. The Perryville Water Company started supplying Perryville with water around 1893. The *Perryville Record* of January 4, 1893, boasted that Perryville would soon enjoy an unlimited source of soft and pure water unexcelled by any in the state, except perhaps in large cities. The Perryville Water Company's reservoir and dam, pictured here, were constructed in 1937. (Courtesy of Wilma Denton.)

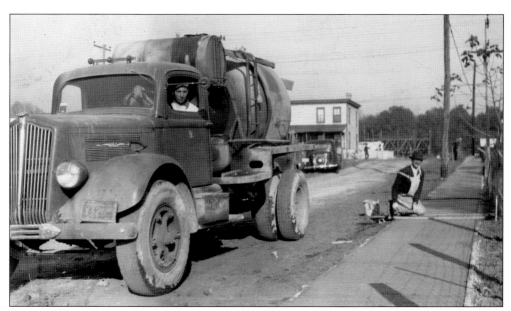

POURING SIDEWALKS ON LOCUST STREET, c. 1950. For many years, Perryville's streets had wooden or slate sidewalks—or no sidewalks at all. Locust Street had no sidewalks until the early 1950s. Here, Willis Gorrell, former mayor of the town and a prominent local contractor, finishes a newly poured sidewalk on Locust Street. Interestingly, Gorrell is wearing a fedora and tie as he works in bib overalls. (Courtesy of Wilma Denton.)

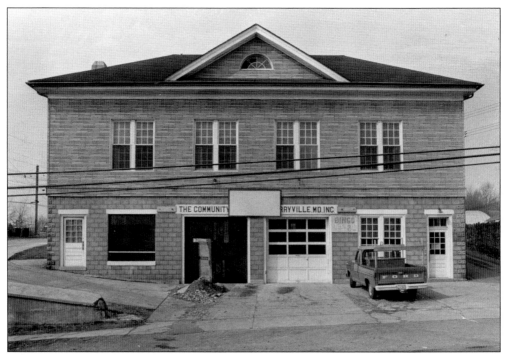

PERRYVILLE'S NEW TOWN HALL. After the Perryville Fire Company built and moved into its new fire hall in 1968, Perryville took ownership of the old building for use as a town hall. This photograph was taken shortly after construction began to convert the facility into office space and meeting rooms. (Courtesy of Historical Society of Cecil County.)

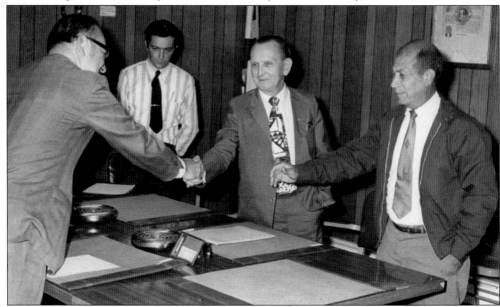

SWEARING-IN OF COMMISSIONERS, 1972. Accepting congratulations after being sworn in as town commissioners of Perryville are Howard "Shorty" Nesbitt (left) and James "Ten-Penny" Jackson. They each served a two-year term, along with three other commissioners. (Courtesy of Historical Society of Cecil County.)

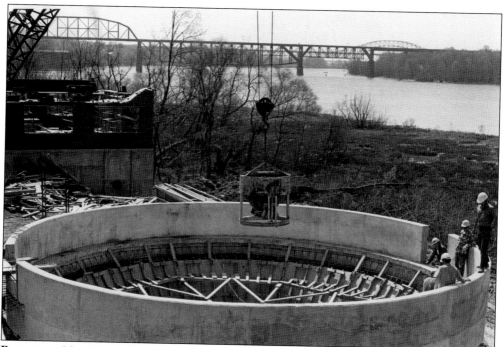

BUILDING A NEW WATER PLANT. In 1973, Perryville began construction of a new, $1-million water plant on the bank of the Susquehanna River. Here, a crane lifts concrete into forms for one of two large sediment basins on the site. (Courtesy of Historical Society of Cecil County.)

CONSTRUCTION SITE INSPECTION. After a walk-through inspection at the water plant site, building progress is discussed. Pictured here are construction supervisor Jack Horner (left), town administrator Frank O'Connell (center), and Mayor Thomas J. Quinlan. (Courtesy of Historical Society of Cecil County.)

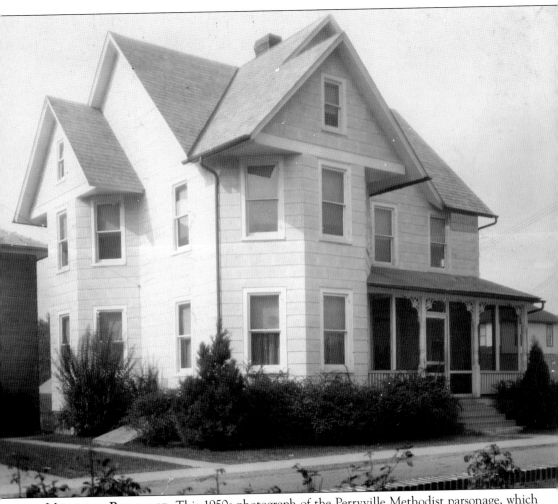

METHODIST PARSONAGE. This 1950s photograph of the Perryville Methodist parsonage, which was built around 1900, shows little change from the way it currently looks. The masonry block church house, which stands to the left in this photograph, between the church and the parsonage, was built in 1928. It was a gift to the church from Mr. and Mrs. William H. Cole Jr. (Courtesy of Cecil Jim Hornberger.)

SALVAGED ANCHOR AT RODGERS TAVERN, 1970. Howard Medholt is shown inspecting an anchor that was brought up from the bottom of the Susquehanna by the Wiley Shipbuilding Company in Port Deposit, Maryland, and donated to Rodgers Tavern. History buffs have long been drawn to the old Perryville inn. (Courtesy of Historical Society of Cecil County.)

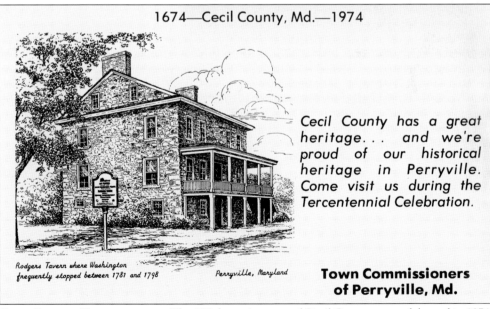

1674—Cecil County, Md.—1974

Cecil County has a great heritage... and we're proud of our historical heritage in Perryville. Come visit us during the Tercentennial Celebration.

Rodgers Tavern where Washington frequently stopped between 1781 and 1798

Perryville, Maryland

Town Commissioners of Perryville, Md.

CECIL COUNTY TERCENTENNIAL. The 300th anniversary of Cecil County was celebrated in 1974. This message from the town commissioners of Perryville, featuring a sketch of historic Rodgers Tavern, was included in the county's commemorative booklet. (Courtesy of Jim Hornberger.)

AMERICAN BICENTENNIAL CELEBRATION. In 1976, the American Freedom Train toured the continental United States. The 26-car train was led by steam engines restored for the celebration, with some of the cars displaying items of historic Americana. From April to December, millions of Americans saw or visited the Freedom Train. It traveled through Perryville in September on its way to Baltimore. The locomotive is on display in the B&O Railroad Museum, located in Baltimore. (Courtesy of Jim Boyd.)

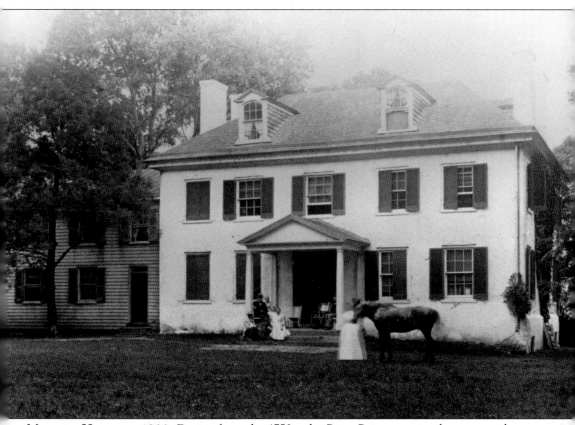

Mansion House, c. 1900. Dating from the 1750s, the Perry Point mansion house served as the Stump family home from 1800 on. The house and 516-acre farm were sold to the federal government in February 1918 for $150,000. In March of that year, construction began on a powder plant that would produce explosives during World War I. The availability of fresh water, railroads, and proximity to shell-loading plants were cited as reasons for the choice of the site. The Atlas Powder Company plant, which included a village area of over 300 houses and support facilities for the company's labor force, was in operation an amazing 124 days later. The US Army Ordnance Corps proclaimed the construction of the plant to be a monument to American ingenuity and resourcefulness. (Courtesy of Perry Point Veterans Museum.)

STUMP FAMILY PORTRAIT. The Stump family, who owned Perry Point for almost a century, posed for a portrait on July 4, 1892. The infant in the photograph is Carrie Stump, who taught school at Perryville High School for many years. (Courtesy of Historical Society of Cecil County.)

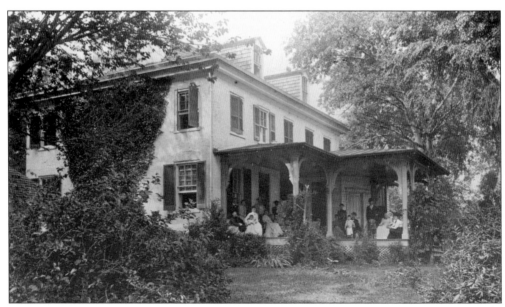

REAR VIEW OF THE MANSION HOUSE. The back of the mansion is shown in this vintage photograph. A large covered porch (which has since been removed), lush landscaping, and mature trees offered shade for the Stump family on a hot Fourth of July in 1892. (Courtesy of Perry Point Veterans Museum.)

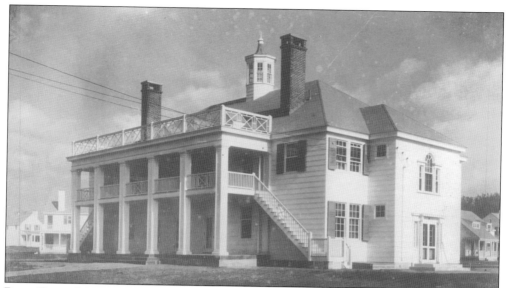

PERRY POINT COMMUNITY CLUB HOUSE, 1918. Built by the Atlas Powder Company as a community center during World War I, the clubhouse functioned as an all-purpose space for parties, meetings, dinners, socials, plays, and a host of other events. It was deemed unsuitable for rehabilitation and razed in 1985. (Courtesy of the author.)

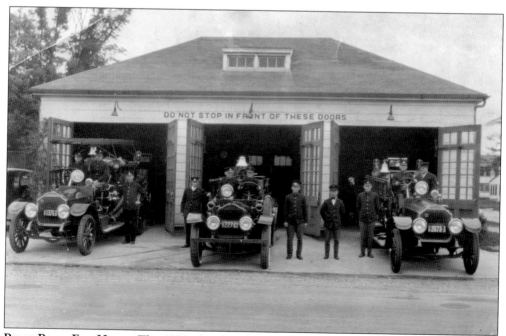

PERRY POINT FIRE HOUSE. This 1920s photograph shows the three-bay firehouse located on Avenue D in the village. This building, although modified and remodeled many times over the years, still serves as the fire company's headquarters. (Courtesy of Historical Society of Cecil County.)

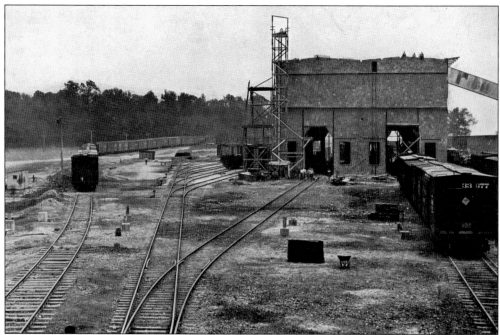

CONSTRUCTION OF THE AMMONIUM NITRATE PLANT, 1918. This is the nearly completed ammonium nitrate storehouse. The storehouse held 14 million pounds of ammonium nitrate. At the time, the Army Ordnance Corps believed this to be this largest quantity of this chemical ever stored in a single building. (Courtesy of Sam Lane.)

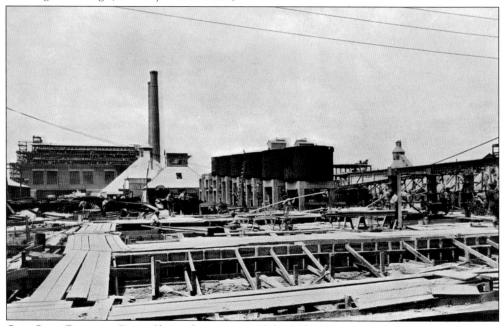

CAST-IRON DIGESTER POTS. Shown here are six of the 16 large cast-iron digester pots that were installed on the floor of one of the chemical production areas. Each of these pots weighed 22 tons. The digester pots were so large that the building was erected around the pots after they were installed. (Courtesy of Sam Lane.)

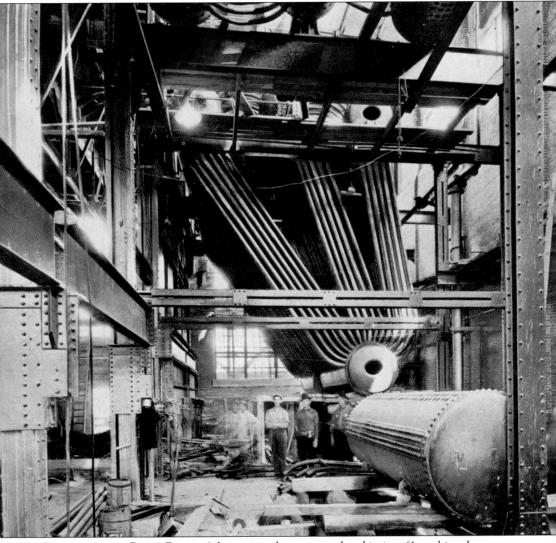

THE POWERHOUSE AT PERRY POINT. A large powerhouse, completed in just 61 working days, was constructed to provide heat and electricity to the plant. The men in this photograph provide some scale for the massive boilers installed in the power plant, which generated around 800 horsepower each. When completed, the powerhouse provided 10,000 horsepower to generators for the plant's electricity. (Courtesy of Sam Lane.)

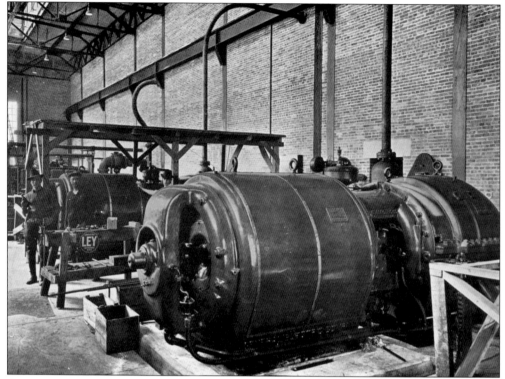

GENERATORS AT THE POWER PLANT. At the time of construction of the plant, electrical power was a commodity not readily available in the Perryville area. To provide electricity to the plant, steam from the boilers was used to power generators. These huge generators were rated at a capacity of 1,000 kilowatts each. (Courtesy of Sam Lane.)

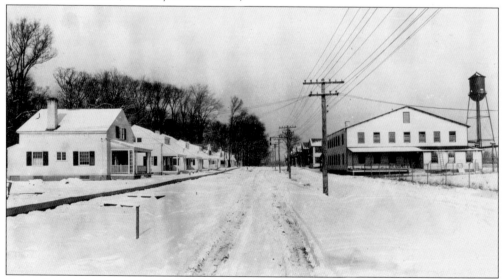

PERRY POINT VILLAGE, C. 1920. This photograph shows Third Street, with the tidy two-story houses of the village situated directly across the street from the industrial facility. A close look reveals a chain-link fence on the right side of the photograph. (Courtesy of Perry Point Veterans Museum.)

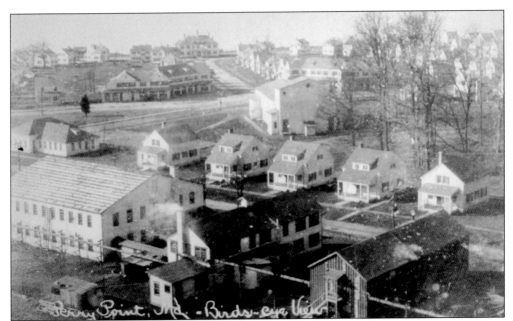

BIRD'S-EYE VIEW OF PERRY POINT, C. 1918. This picture postcard of the Atlas Powder plant shows the housing provided for plant employees. The village area included amenities that may be expected for any town of this size, such as fire, police, and recreation. (Courtesy of Historical Society of Cecil County.)

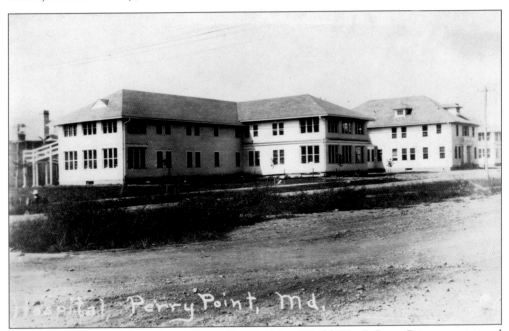

THE PUBLIC HEALTH SERVICE AT PERRY POINT. After World War I, Perry Point transitioned from a munitions plant to a public health service facility and, later, to a Veterans Administration hospital. New wooden hospital buildings replaced many of the original structures. This 1920s photograph shows some of the new facilities. These buildings were later replaced by masonry structures, many of which are still in use. (Courtesy of the author.)

DISCOVER THOUSANDS OF LOCAL HISTORY BOOKS
FEATURING MILLIONS OF VINTAGE IMAGES

Arcadia Publishing, the leading local history publisher in the United States, is committed to making history accessible and meaningful through publishing books that celebrate and preserve the heritage of America's people and places.

Find more books like this at
www.arcadiapublishing.com

Search for your hometown history, your old stomping grounds, and even your favorite sports team.

Consistent with our mission to preserve history on a local level, this book was printed in South Carolina on American-made paper and manufactured entirely in the United States. Products carrying the accredited Forest Stewardship Council (FSC) label are printed on 100 percent FSC-certified paper.

MADE IN THE USA